HOW TO
DRAW
ANYTHING
ANYTIME

A Beginner's Guide to Cute and Easy Doodles

Kamo

TUTTLE Publishing

Tokyo | Rutland, Vermont | Singapore

Contents

Part 1 — Small & Cute Drawings (and Some Easy Ones)

Part 2 — Characters & Icons with All Kinds of Uses

Part 3 — Making Cards and Notes Using Decorative Lettering

Welcome!

Hey, there! I'm Kamo, and I'm an illustrator.

Thanks for choosing my book

My purpose here is twofold: I want to offer you all kinds of cute illustrations while showing you how to draw them. At first glance, some of them may look difficult. But take a closer look. They're just combinations

of circles, squares, dots and wavy lines. Anybody can draw them!

Combining simple shapes opens up a whole new

Oh, wow!

world for the artist and doodler. That world is filled with fun

Just pick up a pen!

and creativity. So let's get started and draw ourselves to a new place!

What You Should Know about Ballpoint Pens

There are various types of pens that differ depending on the type of ink and the thickness of the line they produce. Before we begin, let's take a moment and look at the standard types.

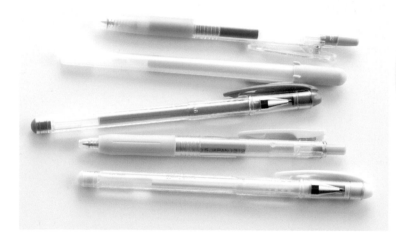

Gel Ink Pens

Ballpoint pens use three types of ink: oil-based, water-based and gel, which is the type I use here. Gel ink is made by adding a gelatinous agent to water-based ink. The result is a smooth line that can be created with little pressure and that doesn't smudge easily. Another plus is they're available in many shades and produce bright, eye-catching colors. The thickness of the line is determined by the thickness of the ball at the pen's tip. The illustrations in this book were made using a 0.5-millimeter tip.

White and Gold Ballpoint Pens

For dark-colored paper, pens with white, gold or silver ink are a strong choice. See pages 6, 44, 79 and 91 for examples.

Pens That Can Draw on Plastic

Made for drawing on plastic and other shiny surfaces, the ink in these pens takes a little while to dry. See page 10 for an example.

Pens That Can Draw on Fabric

Just like with oil-based felt-tip pens, the ink in these pens doesn't come out in the wash. So they're a perfect choice for marking fabric. See page 11 for an example.

When drawing on materials other than paper, make sure to use the right pen and try out a small test area first.

How to Improve Your Drawing Skills

Before we begin, let me answer some frequently asked questions.

I don't have a great eye for colors and I'm worried about using them. Do you have any tips?

Stop worrying and start drawing! Before you begin, pick out three colors to use. If you change your lineup as you're working, no problem.

My drawing's distorted and doesn't look symmetrical. Kamo, help!

Drawing isn't about creating perfectly balanced results, so it's a matter of taste. If you really care about symmetry, flip your paper over and look at your illustration from the back. That makes it easier to notice—and correct—the distortion.

If I practice, will I be able to draw like you?

Of course you will! Not right away, but that's why it's practice. Keep at it, don't overthink and, most of all, have fun!

Right, let's get drawing!

5

Small & Cute Drawings (and Some Easy Ones)

It's fun to be able to draw people, animals, flowers and more!
Here are some easy illustrations that even beginners can draw.

(Use illustrations)

Stationery and envelopes

Add animal motifs to a plain letter to create your own original stationery! Draw a trail of cat footprints using white pen on dark paper for a funny, feline-infused look.

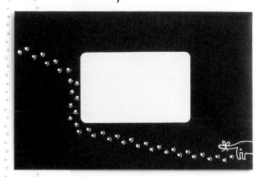

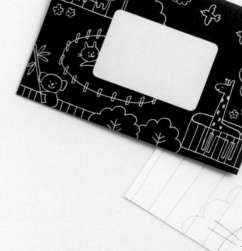

Notepaper

Notepaper is handy for writing little thank you notes or greetings. Match the illustrations and speech bubble to the content of your note to create unique messages.

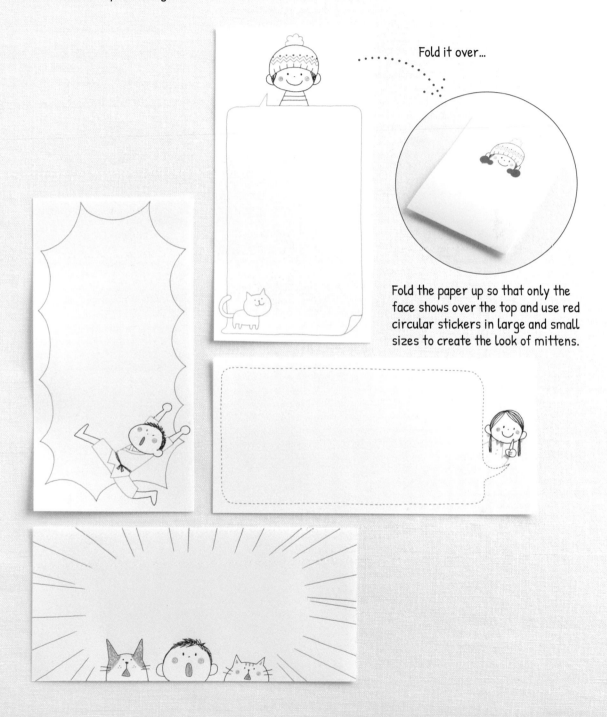

Fold it over…

Fold the paper up so that only the face shows over the top and use red circular stickers in large and small sizes to create the look of mittens.

Recipe file

Adorning your favorite recipes with illustrations makes them easy to identify and adds a cute touch. Use tabs made of colored tape to create a colorful, handy index.

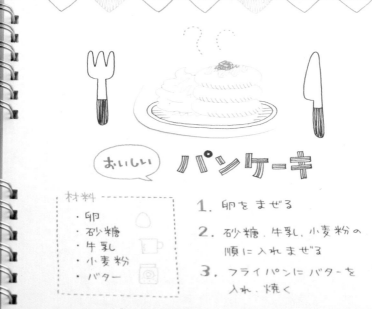

On the title page, use the same masking tape as for the index and draw some pasta for a stylish touch.

Place inside a book...

Place the bookmark inside the book with only the flowers showing, a simple way of saying thanks when returning a borrowed book.

Thank you

Place it inside...

The car appears to be driving along a road.

Use illustrations

Bookmarks

Bookmarks are a great item that you can make by hand and decorate with illustrations. Think of designs that will be effective when only part of them can be seen and the rest is hidden inside the pages of a book.

Decorating plastic objects

Choose ballpoint pens that can be used on plastic to add illustrations to various items and transform plain, transparent objects into highly original pieces.

Decorating fabric items

When drawing with fabric pens, the trick is to
choose simple motifs. Even using black by itself
can create an adorable effect

Let's learn the basic methods for drawing and coloring

For beginners, start by getting used to using ballpoint pens.
If you can draw the basics – lines and circles – you'll be fine.

Let's get used to using ballpoint pens!

Complete this checklist!

① I have a ballpoint pen
YES NO

② I use a ballpoint pen often
YES NO

③ I often write with a ballpoint pen
YES NO

④ I often draw pictures
YES NO

⑤ I am a student
YES NO

⑥ I like drawing
YES NO

moji moji

0–1 "Yes" answers

First of all, hold the pen correctly!

60°

The pen should be on a 60-degree angle

The correct way to hold a pen

2–3 "Yes" answers

Get used to using a ballpoint pen

Try drawing curly and zigzag lines

Get into the habit of writing with or using the pen somehow each day

More than 4 "Yes" answers

Draw more and more!

You're ready to draw, so learn the basics and draw some cute illustrations!

Try drawing straight lines!

Let's start with drawing lines using ballpoint pens. If you can learn to draw the lines and circles that form the foundations of illustrations, you'll be fine.

Straight lines When you're just starting out, draw short lines, making them longer once you've had some practice.

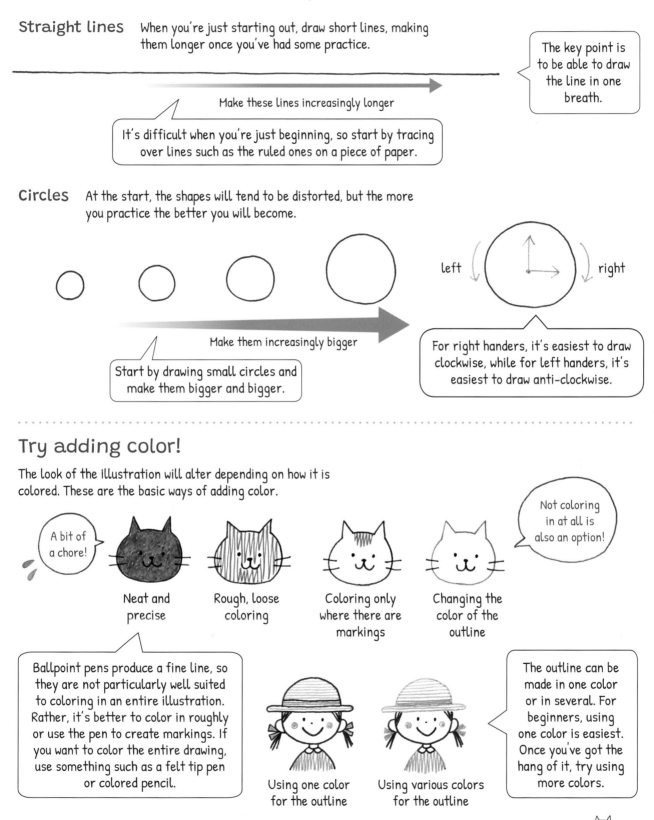

Make these lines increasingly longer

The key point is to be able to draw the line in one breath.

It's difficult when you're just beginning, so start by tracing over lines such as the ruled ones on a piece of paper.

Circles At the start, the shapes will tend to be distorted, but the more you practice the better you will become.

left right

Make them increasingly bigger

Start by drawing small circles and make them bigger and bigger.

For right handers, it's easiest to draw clockwise, while for left handers, it's easiest to draw anti-clockwise.

Try adding color!

The look of the illustration will alter depending on how it is colored. These are the basic ways of adding color.

A bit of a chore!

Not coloring in at all is also an option!

Neat and precise

Rough, loose coloring

Coloring only where there are markings

Changing the color of the outline

Ballpoint pens produce a fine line, so they are not particularly well suited to coloring in an entire illustration. Rather, it's better to color in roughly or use the pen to create markings. If you want to color the entire drawing, use something such as a felt tip pen or colored pencil.

Using one color for the outline

Using various colors for the outline

The outline can be made in one color or in several. For beginners, using one color is easiest. Once you've got the hang of it, try using more colors.

13

Master the basic techniques needed to draw people

Once you master the basics for drawing human figures, you'll be able to draw men and women of all ages. After you get it down, you'll get the knack, you'll even be able to depict movement in illustrations.

The basics are crucial

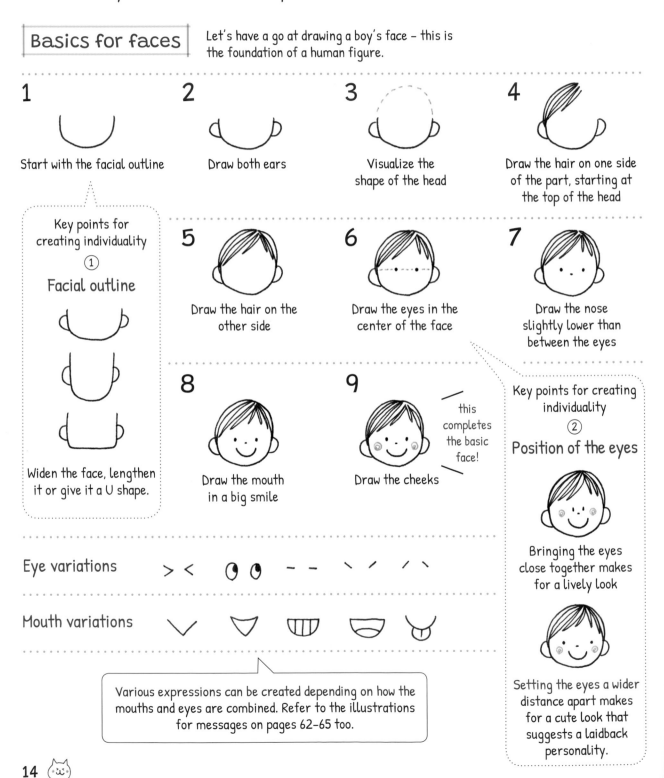

Basics for faces

Let's have a go at drawing a boy's face - this is the foundation of a human figure.

1 Start with the facial outline

2 Draw both ears

3 Visualize the shape of the head

4 Draw the hair on one side of the part, starting at the top of the head

Key points for creating individuality
① Facial outline

Widen the face, lengthen it or give it a U shape.

5 Draw the hair on the other side

6 Draw the eyes in the center of the face

7 Draw the nose slightly lower than between the eyes

8 Draw the mouth in a big smile

9 Draw the cheeks

this completes the basic face!

Key points for creating individuality
② Position of the eyes

Bringing the eyes close together makes for a lively look

Setting the eyes a wider distance apart makes for a cute look that suggests a laidback personality.

Eye variations > < ◖ ◗ - - ` ` ′ `

Mouth variations

Various expressions can be created depending on how the mouths and eyes are combined. Refer to the illustrations for messages on pages 62–65 too.

14

Girls' hairstyles

Simply alter the basic boy's hairstyle to create all kinds of hairstyles for girls.

Add pigtails to a basic look Simply adding pigtails creates a cute look.

Pigtails

Braids

Low ponytail

High ponytail

Variations on bangs and buns Create various arrangements by altering the bangs' length and part and the position and number of buns.

Straight bangs
+ two buns

Side parting
+ One bun

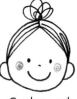

Center part
+ loose bun

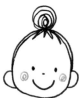

Short bangs
+ Tight bun

Hairstyles that cover the ears Hair that hangs next to the face makes for a completely different look.

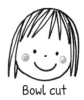

Bowl cut

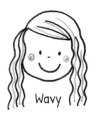

Long and
straight

Bangs

Wavy

Boys' hairstyles

Altering the bangs and side sections of the basic boys' hairstyle allows you to change the age and general vibe.

Variations on the basic style Simply changing the length of the hair makes the character look different.

Shorter than basic style

Even shorter

Longer than basic style

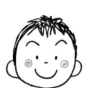

Shaved sides

Adding accessories and features Try adding accessories, a beard and so on to create variations in male figures.

Glasses

Beard

Hat

Draw eyebrows

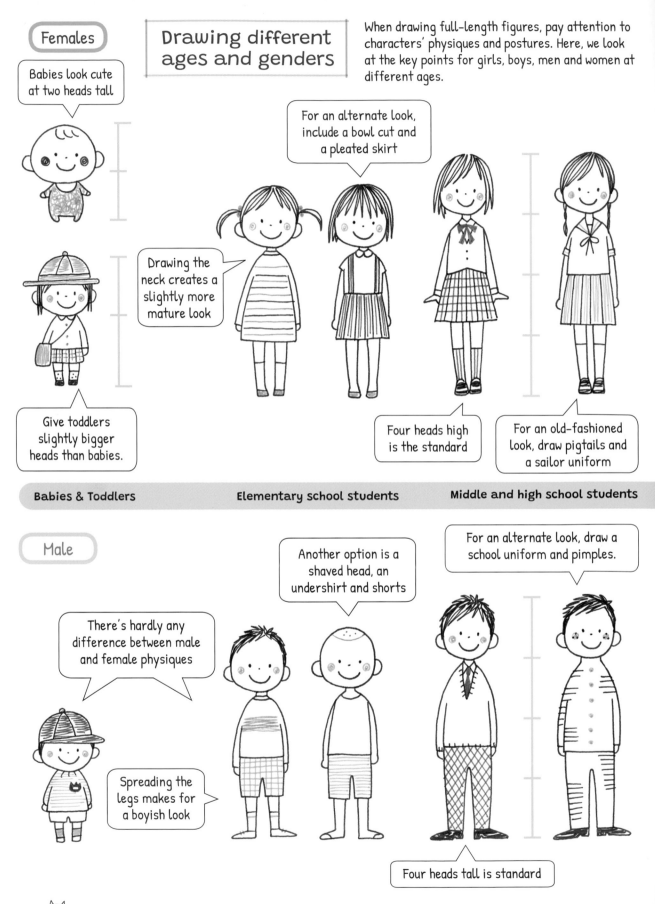

Females

Drawing different ages and genders

When drawing full-length figures, pay attention to characters' physiques and postures. Here, we look at the key points for girls, boys, men and women at different ages.

Babies look cute at two heads tall

For an alternate look, include a bowl cut and a pleated skirt

Drawing the neck creates a slightly more mature look

Give toddlers slightly bigger heads than babies.

Four heads high is the standard

For an old-fashioned look, draw pigtails and a sailor uniform

Babies & Toddlers　　　　**Elementary school students**　　　**Middle and high school students**

Male

For an alternate look, draw a school uniform and pimples.

Another option is a shaved head, an undershirt and shorts

There's hardly any difference between male and female physiques

Spreading the legs makes for a boyish look

Four heads tall is standard

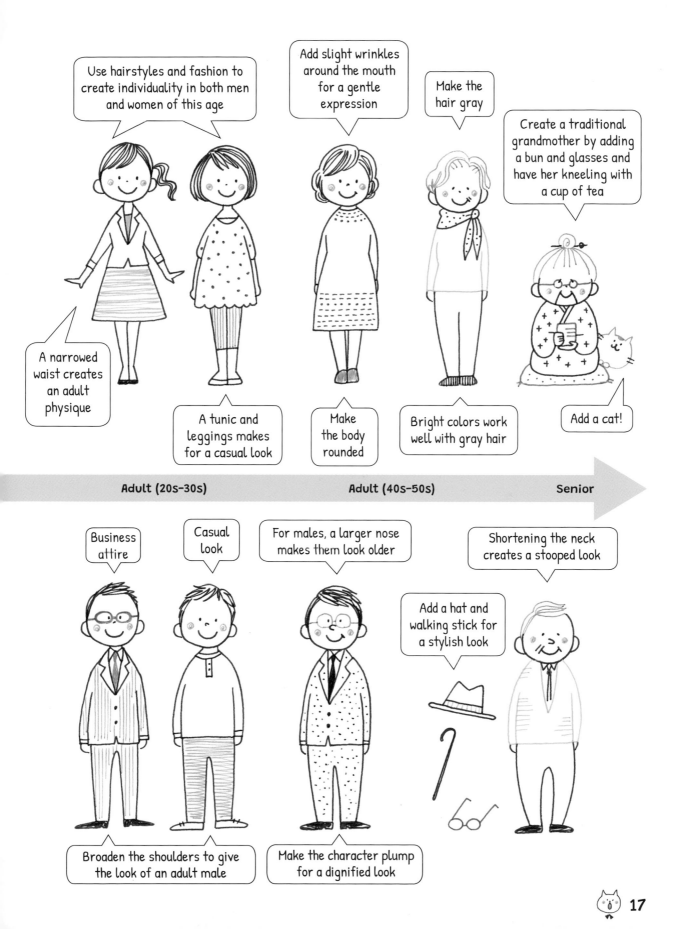

Movement

If you pay attention to details such as proportions and movements in the joints as you go, you'll be able to draw figures in motion.

First, use circles to draw!

Make sure the head and body balance

Four heads tall
This is the standard balance between head and body, easiest for creating movement

Two heads tall
For a child, this is the best head-to-body ratio to use

Six heads tall
This ratio resembles the actual human figure

How to depict motion in the entire body

Keep the movement of the joints in mind and draw the pose, then flesh it out. Here, we'll use a figure four heads tall

Make the figure move like so

Visualize this motion to make it easier to draw. It's fine to draw lightly with pencil until you get used to it.

Make sure to check the joints when the figure is in motion!

Draw the face (see pages 14-15)

Draw the body (see pages 16-17)

Erase the sketch lines and add in the lines of the clothing.

Make light dabbing motions with the eraser to get rid of sketch lines.

How to depict motion in the face

Varying the position of facial elements allows you to change the way the face is pointing.

Front view

Looking up

Looking down

Side view

Draw the hair, eyes, nose and mouth higher up on the face

Draw plenty of hair and lower the eyes, nose and mouth.

Extend the nose

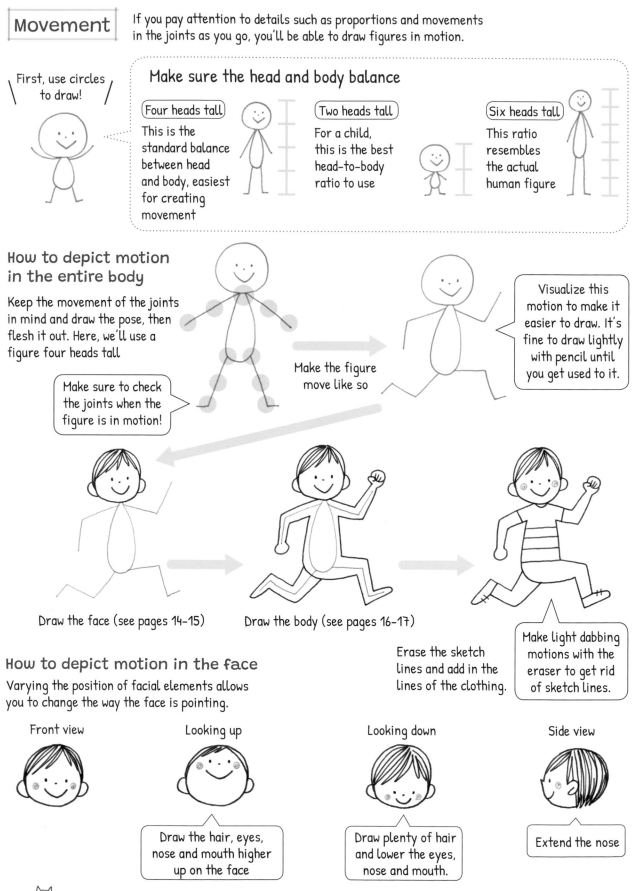

Various movements

Flesh out the figure using circles and lines. Once you've had some practice, pay more attention to the finer details in the hands and feet, the wrinkles in clothes and so on.

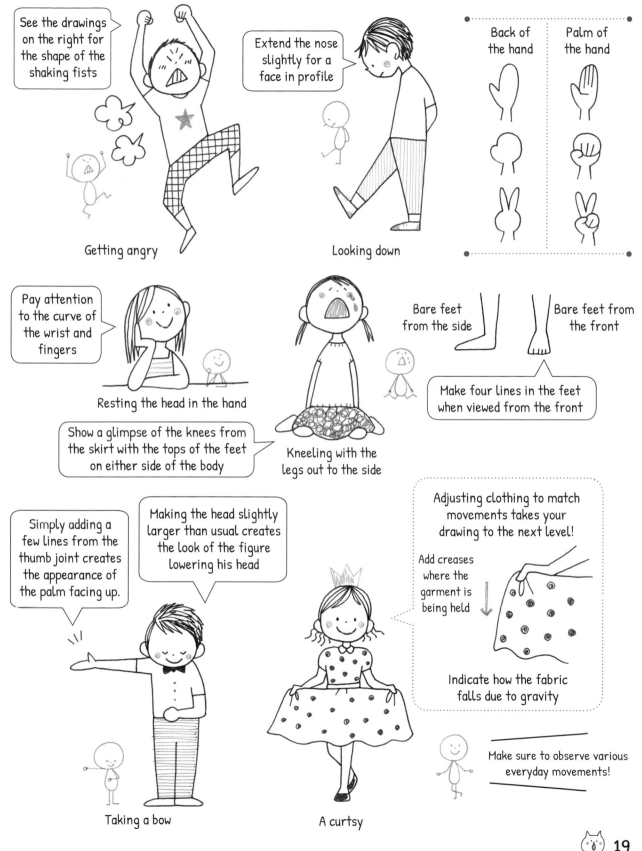

See the drawings on the right for the shape of the shaking fists

Extend the nose slightly for a face in profile

Back of the hand

Palm of the hand

Getting angry

Looking down

Pay attention to the curve of the wrist and fingers

Resting the head in the hand

Show a glimpse of the knees from the skirt with the tops of the feet on either side of the body

Kneeling with the legs out to the side

Bare feet from the side

Bare feet from the front

Make four lines in the feet when viewed from the front

Simply adding a few lines from the thumb joint creates the appearance of the palm facing up.

Making the head slightly larger than usual creates the look of the figure lowering his head

Adjusting clothing to match movements takes your drawing to the next level!

Add creases where the garment is being held

Indicate how the fabric falls due to gravity

Taking a bow

A curtsy

Make sure to observe various everyday movements!

19

For animals, the outline and the ears are key

The outline and ears are key points when drawing various animals. If you can capture their characteristics, you can draw any animal from pets to wildlife.

Alterations make it possible to draw all kinds of animals!

Order in which to draw

Decide on the animal to draw → Picture it or look at reference material → Draw!

How to draw a bear

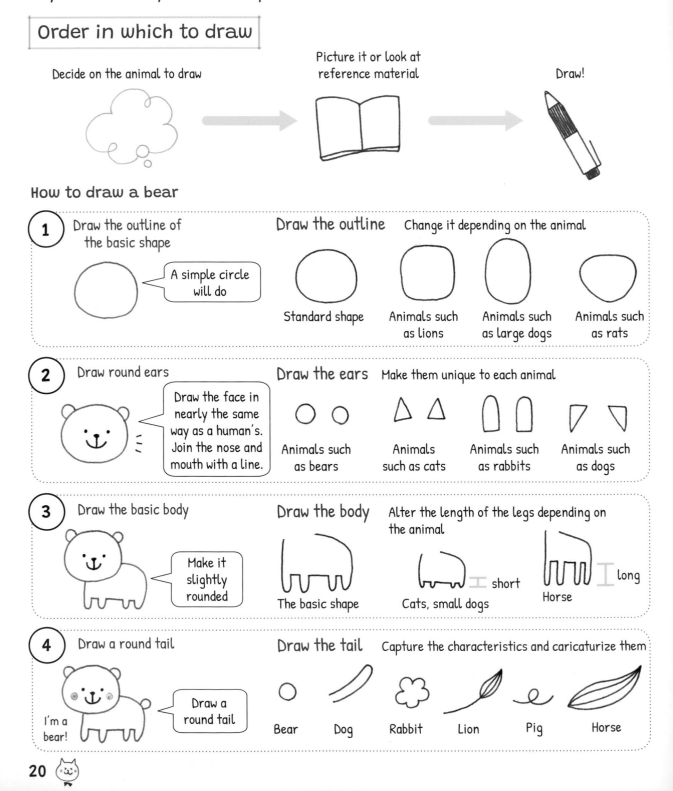

1 Draw the outline of the basic shape

A simple circle will do

Draw the outline — Change it depending on the animal

Standard shape · Animals such as lions · Animals such as large dogs · Animals such as rats

2 Draw round ears

Draw the face in nearly the same way as a human's. Join the nose and mouth with a line.

Draw the ears — Make them unique to each animal

Animals such as bears · Animals such as cats · Animals such as rabbits · Animals such as dogs

3 Draw the basic body

Make it slightly rounded

Draw the body — Alter the length of the legs depending on the animal

The basic shape · Cats, small dogs — short · Horse — long

4 Draw a round tail

Draw a round tail

I'm a bear!

Draw the tail — Capture the characteristics and caricaturize them

Bear · Dog · Rabbit · Lion · Pig · Horse

Various animals

Try drawing various animals using the drawing methods on the previous page! Emphasize the characteristics of their bodies and consider how to color them too.

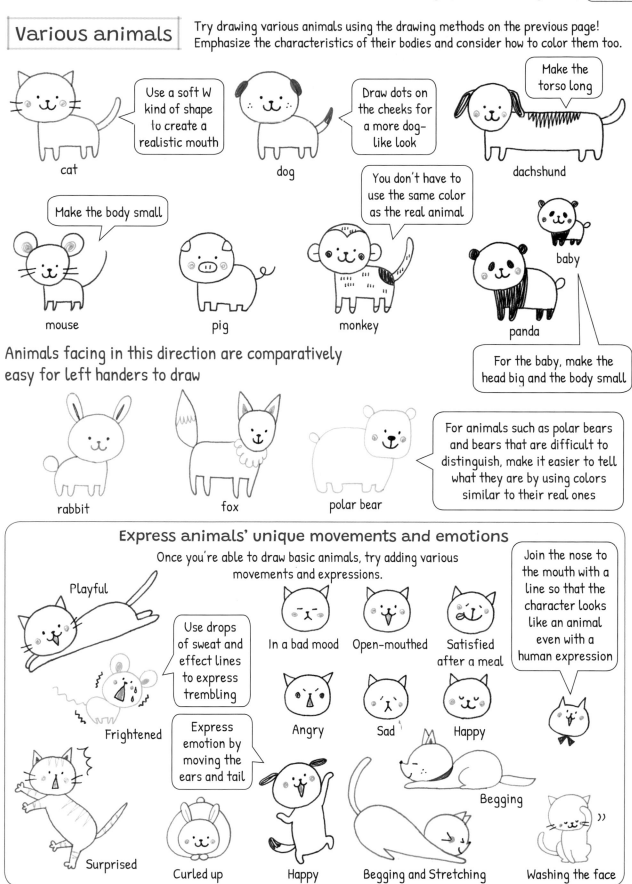

Use a soft W kind of shape to create a realistic mouth

cat

Draw dots on the cheeks for a more dog-like look

dog

Make the torso long

dachshund

Make the body small

mouse

pig

You don't have to use the same color as the real animal

monkey

baby

panda

For the baby, make the head big and the body small

Animals facing in this direction are comparatively easy for left handers to draw

rabbit

fox

polar bear

For animals such as polar bears and bears that are difficult to distinguish, make it easier to tell what they are by using colors similar to their real ones

Express animals' unique movements and emotions

Once you're able to draw basic animals, try adding various movements and expressions.

Playful

Join the nose to the mouth with a line so that the character looks like an animal even with a human expression

Use drops of sweat and effect lines to express trembling

In a bad mood Open-mouthed Satisfied after a meal

Frightened

Express emotion by moving the ears and tail

Angry Sad Happy

Surprised

Curled up Happy Begging and Stretching

Begging

Washing the face

21

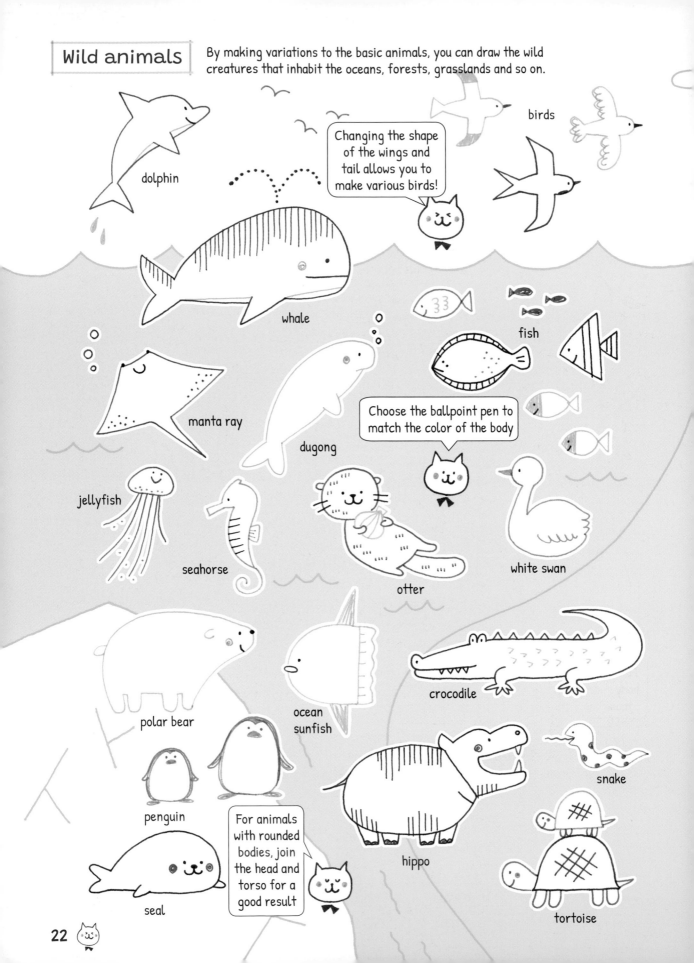

Wild animals

By making variations to the basic animals, you can draw the wild creatures that inhabit the oceans, forests, grasslands and so on.

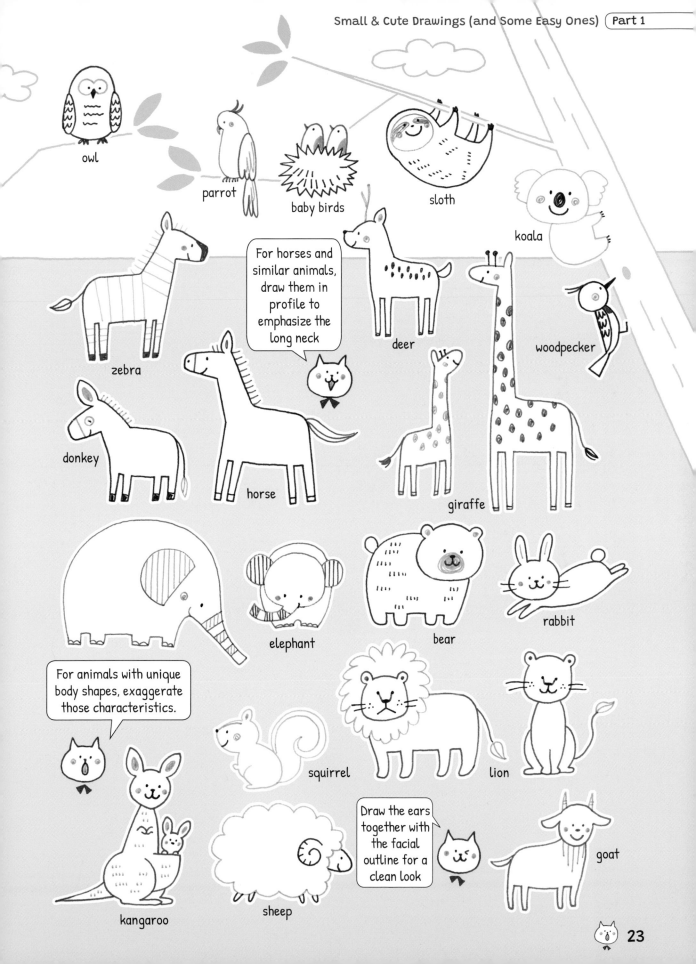

owl

parrot

baby birds

sloth

koala

zebra

For horses and similar animals, draw them in profile to emphasize the long neck

deer

giraffe

woodpecker

donkey

horse

elephant

bear

rabbit

For animals with unique body shapes, exaggerate those characteristics.

squirrel

lion

Draw the ears together with the facial outline for a clean look

goat

kangaroo

sheep

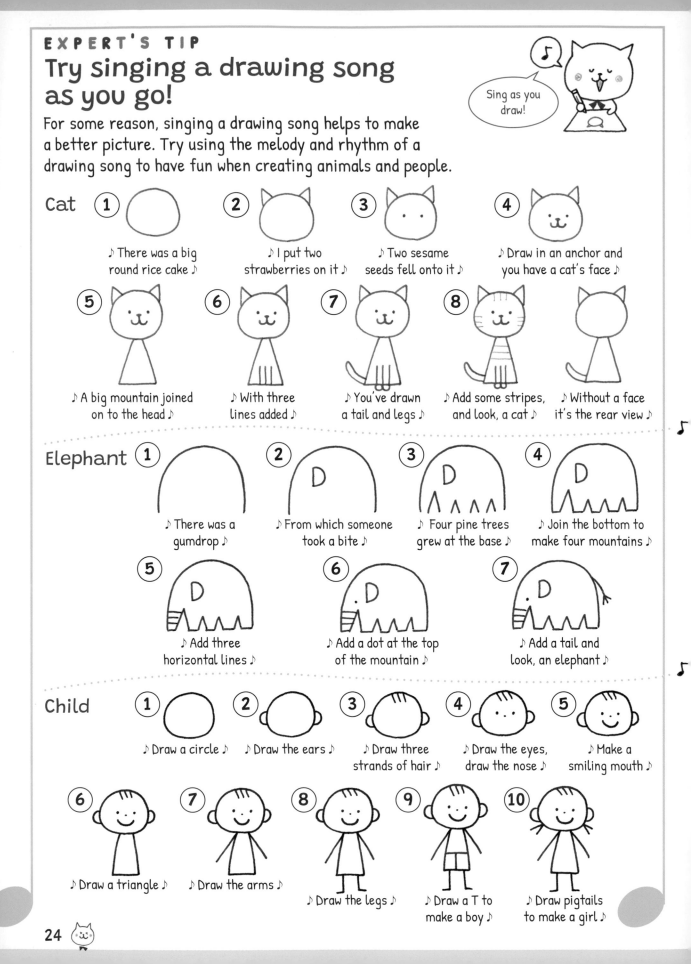

EXPERT'S TIP
Try singing a drawing song as you go!

For some reason, singing a drawing song helps to make a better picture. Try using the melody and rhythm of a drawing song to have fun when creating animals and people.

Sing as you draw!

Cat

1 ♪ There was a big round rice cake ♪

2 ♪ I put two strawberries on it ♪

3 ♪ Two sesame seeds fell onto it ♪

4 ♪ Draw in an anchor and you have a cat's face ♪

5 ♪ A big mountain joined on to the head ♪

6 ♪ With three lines added ♪

7 ♪ You've drawn a tail and legs ♪

8 ♪ Add some stripes, and look, a cat ♪

♪ Without a face it's the rear view ♪

Elephant

1 ♪ There was a gumdrop ♪

2 ♪ From which someone took a bite ♪

3 ♪ Four pine trees grew at the base ♪

4 ♪ Join the bottom to make four mountains ♪

5 ♪ Add three horizontal lines ♪

6 ♪ Add a dot at the top of the mountain ♪

7 ♪ Add a tail and look, an elephant ♪

Child

1 ♪ Draw a circle ♪

2 ♪ Draw the ears ♪

3 ♪ Draw three strands of hair ♪

4 ♪ Draw the eyes, draw the nose ♪

5 ♪ Make a smiling mouth ♪

6 ♪ Draw a triangle ♪

7 ♪ Draw the arms ♪

8 ♪ Draw the legs ♪

9 ♪ Draw a T to make a boy ♪

10 ♪ Draw pigtails to make a girl ♪

Try drawing someone's face!

Once you can draw a basic face, try drawing someone you know! The trick is to look carefully at the face and highlight parts that are different from your own!

Get a grasp of the characteristics!

Start off with a face you're used to drawing!

The standard face on page 14 starts to resemble your own once you've drawn it a bit.

Use this as the standard from which to draw various people's faces!

Look carefully at the face of the person you are drawing...

Use the parts that are different from your own to set their face apart!

Hello

position of eyes

hairstyle

outline

nose

Example

• Narrow face
• Eyes are close together
• Well-defined bridge of nose

• Pointed chin
• Large eyes (it's fine to draw eyelashes too)
• Unique hairstyle

Don't stare at the person's face for too long; simply take a glance and work out what the unique features are, then exaggerate them.

Don't think, just draw!

• Round nose
• Downward-facing eyebrows

• Glasses make for a serious look
• The look of the mouth when smiling is also a key point

※ For males, particularly emphasize the nose and eyebrows

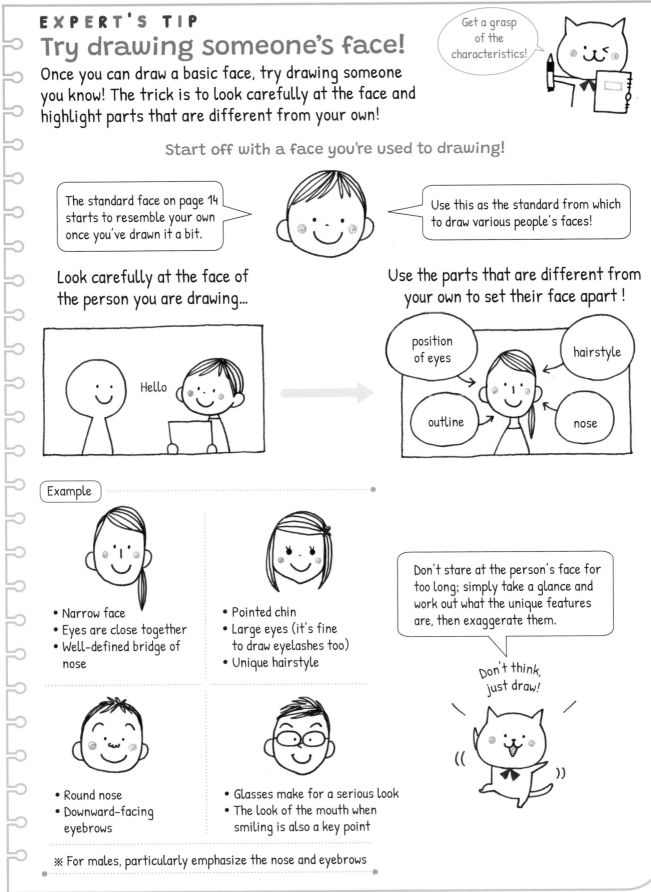

Exaggerate flowers' characteristics

It's easy

Rather than pursuing realism when drawing flowers, go for roughly capturing the characteristics. A slightly off-balance bloom makes for a cute look, so go bold and don't be afraid of making mistakes.

Flowers, plants and trees can all be drawn by combining simple shapes. Once you can draw the basic shapes, make some different ones and try putting them together in a variety of ways.

Try drawing basic shapes

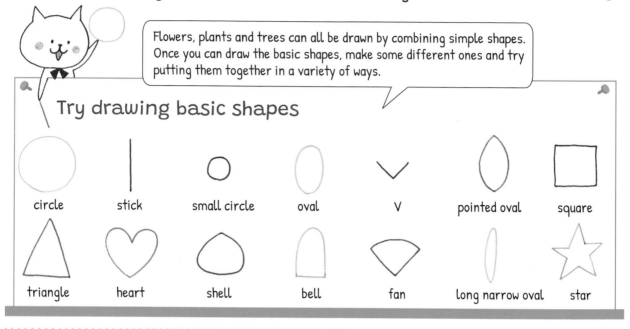

| circle | stick | small circle | oval | V | pointed oval | square |

| triangle | heart | shell | bell | fan | long narrow oval | star |

Flowers | Have a go at drawing flowers that everyone knows. It's only a matter of combining simple shapes to make the flowers and leaves, so it's easy.

Basic flowers

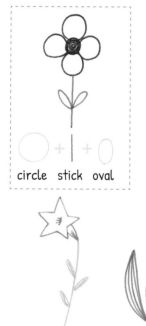

circle stick oval

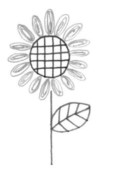

Sunflower

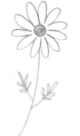

Marguerite Daisy

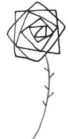

Rose

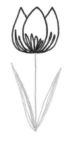

Tulip

Bellflower

Lily of the valley

Pansy

Cosmos

Dandelion

Trees

If you use a stick and a circle as the basics, it's nearly impossible to make a mistake even when rearranging these elements. Use scribbly strokes and stripes to finish your tree.

Basic trees

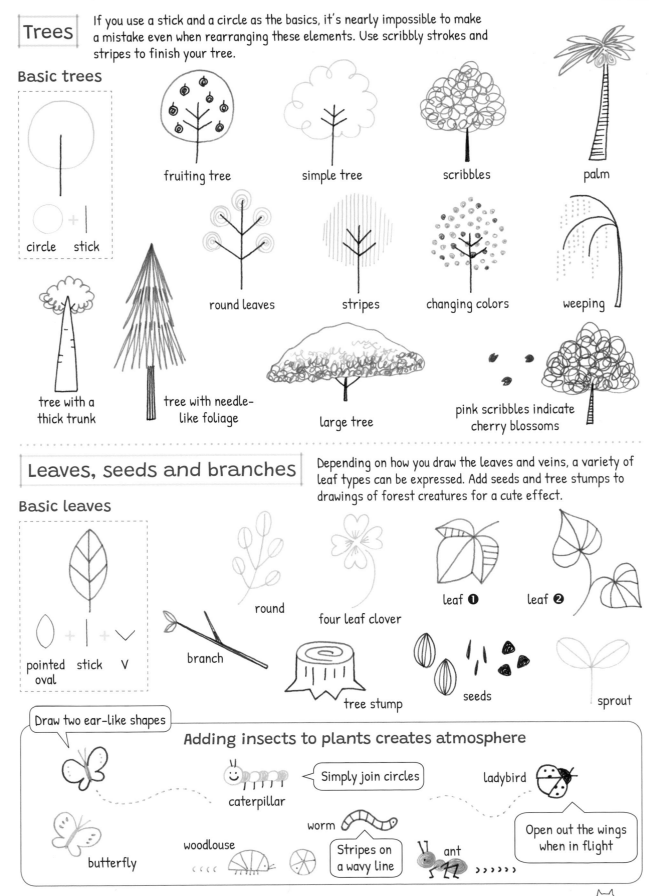

circle stick

fruiting tree

simple tree

scribbles

palm

round leaves

stripes

changing colors

weeping

tree with a thick trunk

tree with needle-like foliage

large tree

pink scribbles indicate cherry blossoms

Leaves, seeds and branches

Depending on how you draw the leaves and veins, a variety of leaf types can be expressed. Add seeds and tree stumps to drawings of forest creatures for a cute effect.

Basic leaves

pointed oval stick V

branch

round

four leaf clover

leaf ❶

leaf ❷

tree stump

seeds

sprout

Draw two ear-like shapes

Adding insects to plants creates atmosphere

caterpillar

Simply join circles

ladybird

butterfly

woodlouse

worm

Stripes on a wavy line

ant

Open out the wings when in flight

27

For food, as long as you get the shape right it's O.K.

Compared with people and animals, food is relatively easy to have a go at drawing. Add some to letters, notes or a recipe card to pass along.

That looks delicious!

Look at the overall shape

Think of it as a basic form

\ round /
cabbage

\ inverted triangle /
spinach

\ rounded oblong /
Chinese cabbage

\ long and narrow /
leek

Get the characteristics right

Observe the unique parts of each food

inverted triangle
carrot

straight
daikon radish

pointed tip
turnip

gentle curve

Vegetables and so on

On close inspection, vegetables have unique shapes.
Start by looking at real vegetables to draw them.

mushroom

shiitake

orange/red peppers

bell pepper

cauliflower

broccoli

radish

king oyster mushroom

enoki mushrooms

scallions

sugar pea

okra

green bean

cucumber

asparagus

pumpkin

lettuce

chili pepper

potato

yam

tomato

cherry tomatoes

onion

bamboo shoot

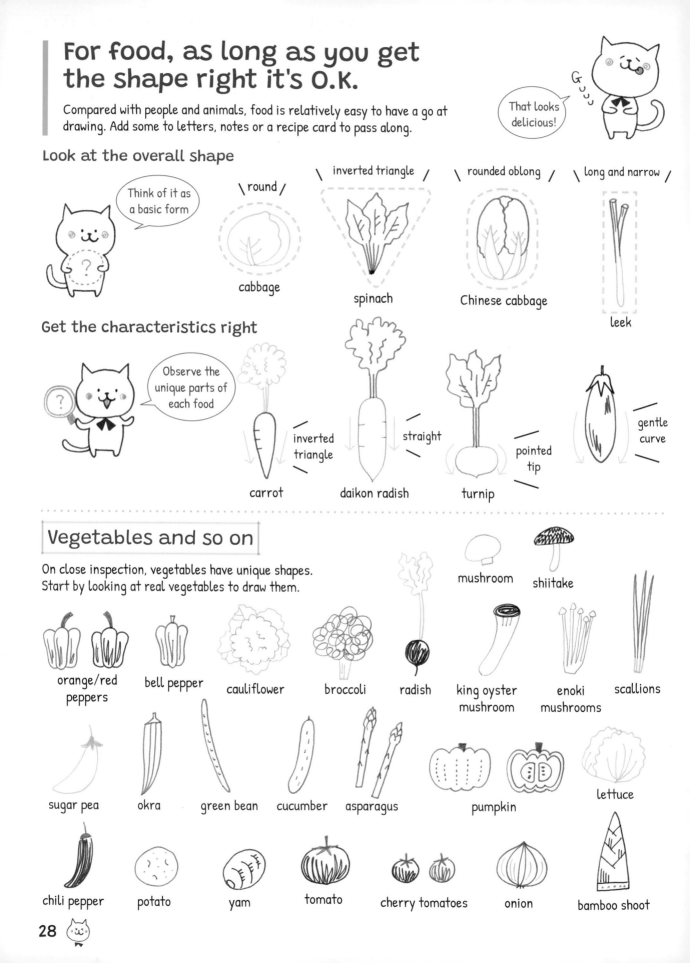

Fruit

Fruit is colorful, so it's a good idea to color it in. Use patterns and markings to skilfully indicate the surface texture.

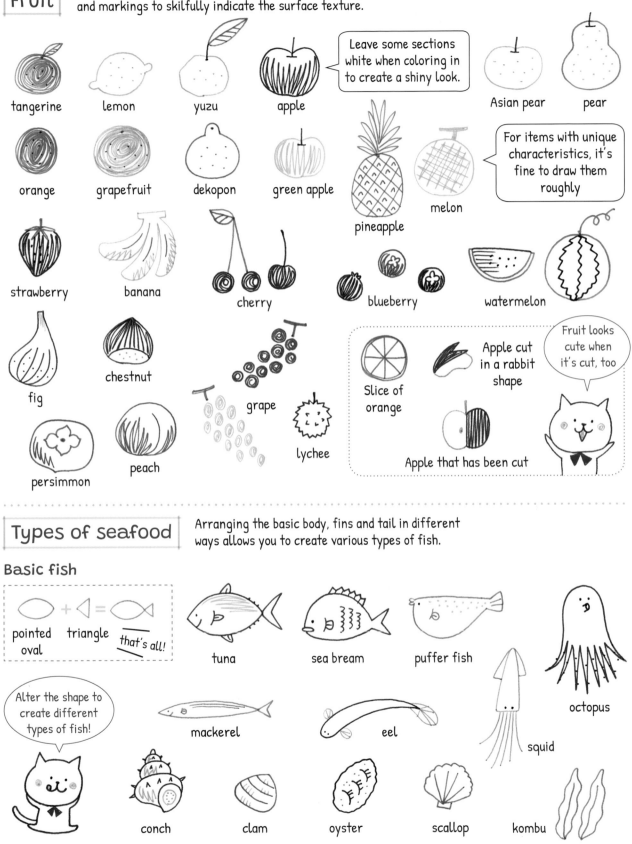

tangerine lemon yuzu apple

> Leave some sections white when coloring in to create a shiny look.

Asian pear pear

orange grapefruit dekopon green apple pineapple melon

> For items with unique characteristics, it's fine to draw them roughly

strawberry banana cherry blueberry watermelon

fig chestnut grape lychee

persimmon peach

Slice of orange

Apple cut in a rabbit shape

Apple that has been cut

> Fruit looks cute when it's cut, too

Types of seafood

Arranging the basic body, fins and tail in different ways allows you to create various types of fish.

Basic fish

pointed oval + triangle = that's all!

tuna sea bream puffer fish octopus

> Alter the shape to create different types of fish!

mackerel eel squid

conch clam oyster scallop kombu

Snacks, bread, drinks

Cute sweets look just like toys. Tweak the packaging, toppings and so on for a bright, showy look.

diagonal? \from above?/
from the side?

The first thing to do is to work out which angle is the best choice.

Snacks

macarons madeleine jelly beans donuts candy

sheet cake churros jello block of chocolate Japanese sweets strawberry rice flour cake

popcorn

It's OK if the lines overlap!

birthday cake lollipop pudding cookies and crackers

pancakes Swiss roll cheesecake Bundt cake rice cracker thin rice cakes

traditional candies steamed bun

For drinks whose contents are hard to see, add a picture

Bread

Drinks

café au lait blender

raisin roll melon bread

This is most delicious

baguette loaf of bread toast with butter and jelly soft drink soda cream soda

cream horn croissant cream bread matcha

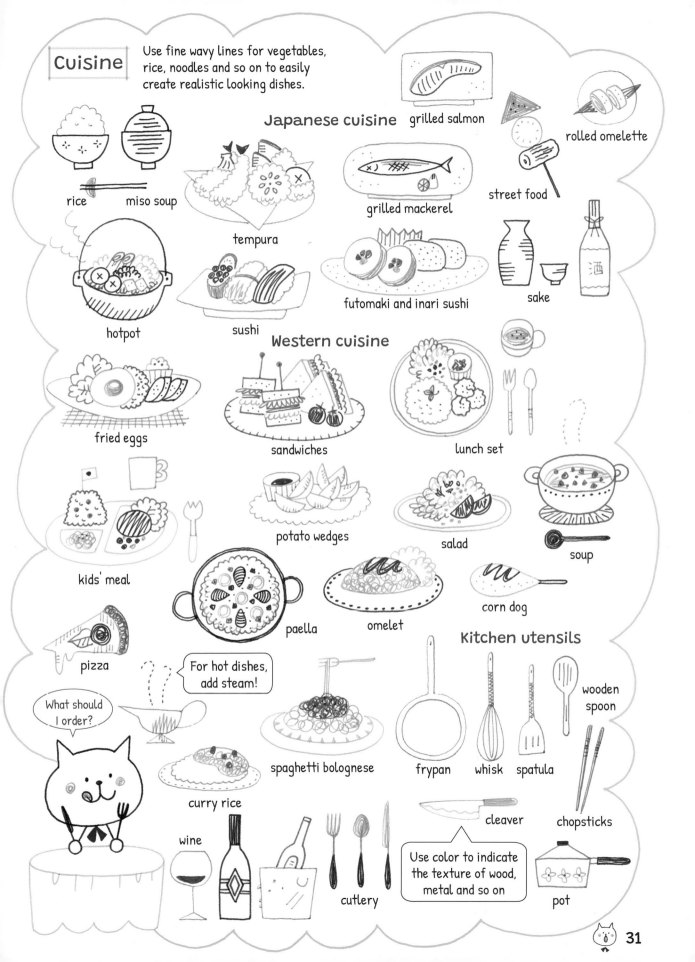

Cuisine

Use fine wavy lines for vegetables, rice, noodles and so on to easily create realistic looking dishes.

Japanese cuisine

grilled salmon

rolled omelette

street food

rice miso soup

tempura

grilled mackerel

futomaki and inari sushi

sake

hotpot sushi

Western cuisine

fried eggs

sandwiches

lunch set

kids' meal

potato wedges

salad

soup

corn dog

paella omelet

Kitchen utensils

pizza

For hot dishes, add steam!

What should I order?

spaghetti bolognese

frypan whisk spatula

wooden spoon

curry rice

chopsticks

cleaver

wine

Use color to indicate the texture of wood, metal and so on

cutlery

pot

Tweak styles and patterns when drawing fashions

Fashions are surprisingly important when drawing people. Well-drawn styles of clothing and accessories make for stylish illustrations.

Check out the trends!

Women's fashions

Use plenty of color to create bright outfits for women.

Ways to wear a hat

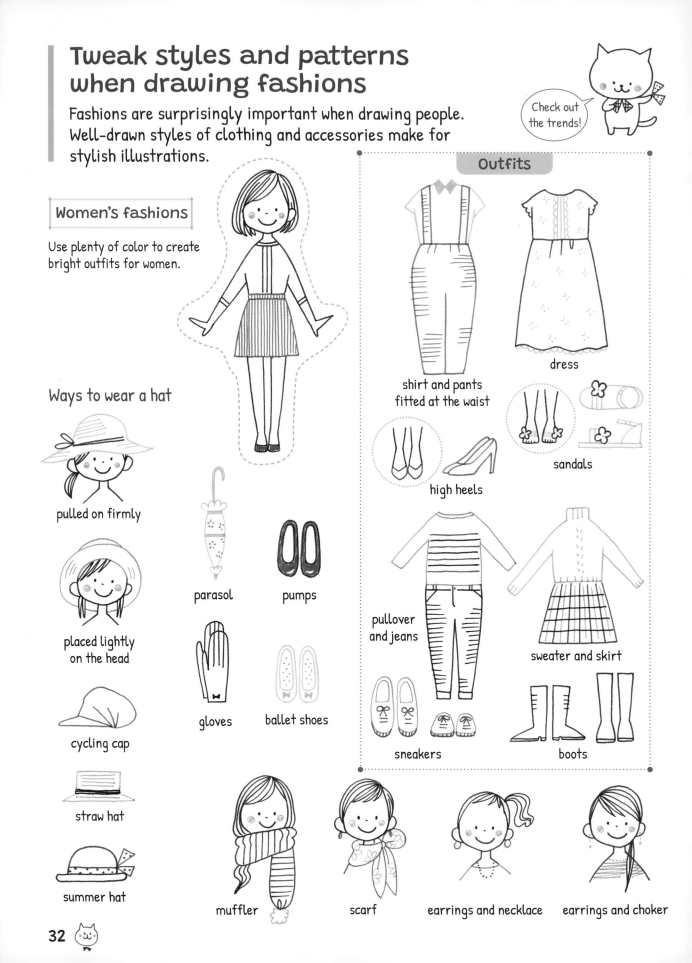

pulled on firmly

placed lightly on the head

cycling cap

straw hat

summer hat

parasol

pumps

gloves

ballet shoes

Outfits

shirt and pants fitted at the waist

dress

high heels

sandals

pullover and jeans

sweater and skirt

sneakers

boots

muffler

scarf

earrings and necklace

earrings and choker

32

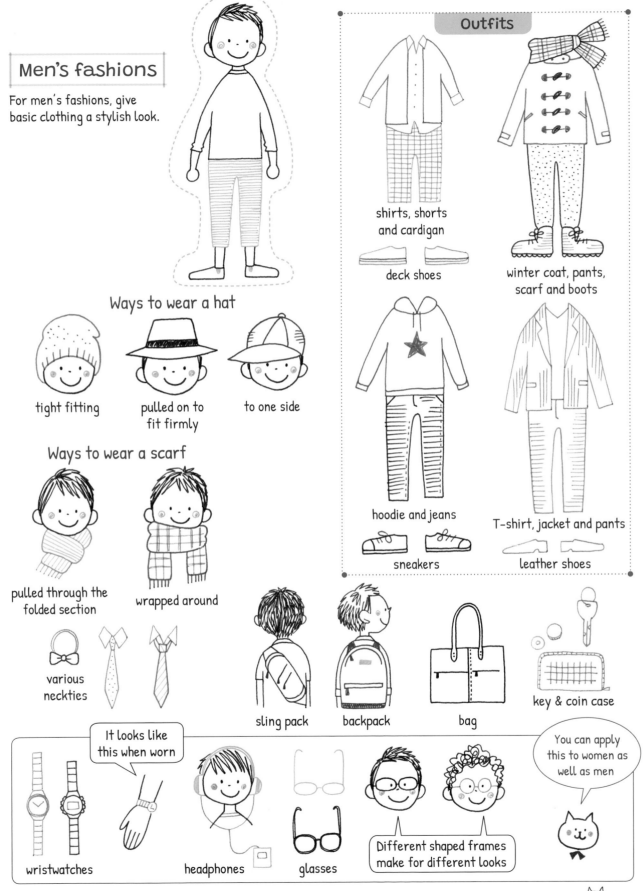

Men's fashions

For men's fashions, give basic clothing a stylish look.

Outfits

shirts, shorts and cardigan

deck shoes

winter coat, pants, scarf and boots

hoodie and jeans

sneakers

T-shirt, jacket and pants

leather shoes

Ways to wear a hat

tight fitting

pulled on to fit firmly

to one side

Ways to wear a scarf

pulled through the folded section

wrapped around

various neckties

sling pack

backpack

bag

key & coin case

It looks like this when worn

wristwatches

headphones

glasses

Different shaped frames make for different looks

You can apply this to women as well as men

Keep knickknacks and small items simple

The charm of little decorative items is in their cozy cuteness. Don't draw in too much detail, just make sure to capture the overall vibe of the item.

Draw your favorite things!

Knickknacks and small items

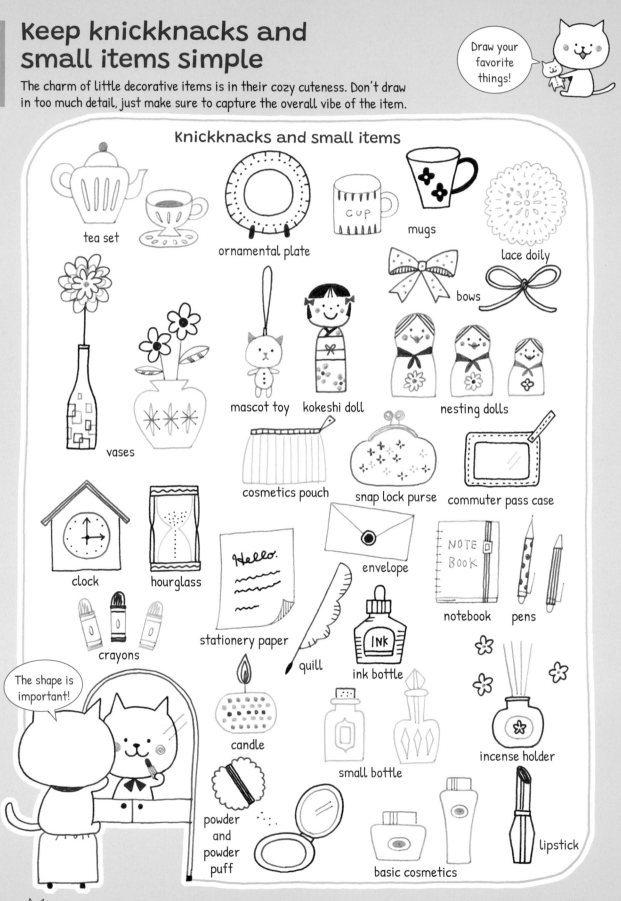

tea set

ornamental plate

mugs

lace doily

bows

vases

mascot toy

kokeshi doll

nesting dolls

cosmetics pouch

snap lock purse

commuter pass case

clock

hourglass

stationery paper

Hello.

envelope

NOTE BOOK

notebook

pens

crayons

quill

ink bottle

INK

candle

small bottle

incense holder

The shape is important!

powder and powder puff

basic cosmetics

lipstick

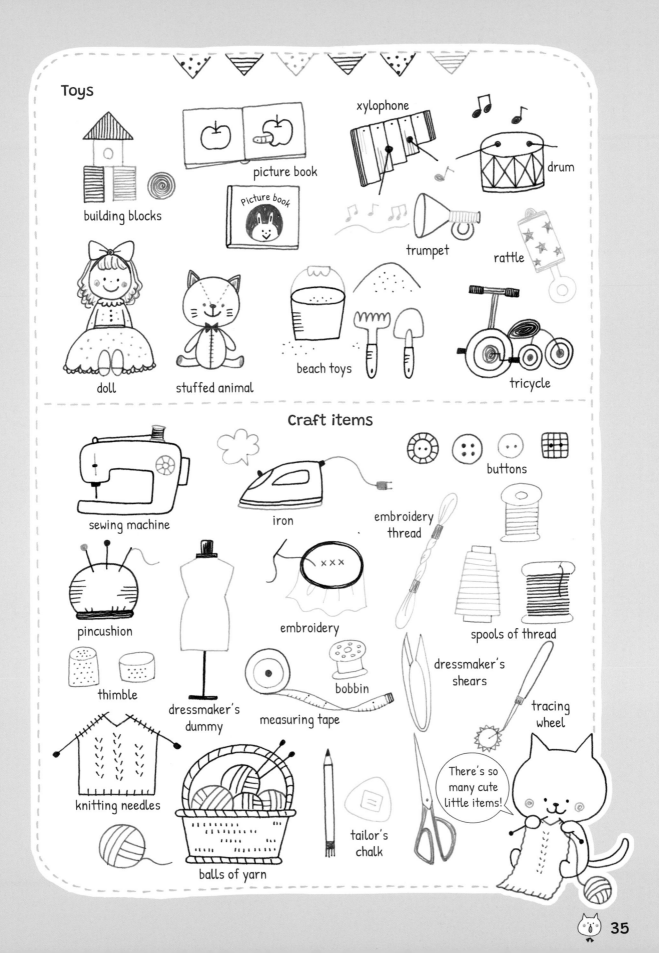

Toys

building blocks

picture book

xylophone

drum

picture book

trumpet

rattle

doll

stuffed animal

beach toys

tricycle

Craft items

sewing machine

iron

buttons

embroidery
thread

pincushion

embroidery

spools of thread

thimble

dressmaker's
dummy

measuring tape

bobbin

dressmaker's
shears

tracing
wheel

knitting needles

balls of yarn

tailor's
chalk

There's so
many cute
little items!

Draw right down to the finer details for household items

For items in and around the house, add in distinguishing details to make your drawing distinctive.

Use color and pattern for a stylish look!

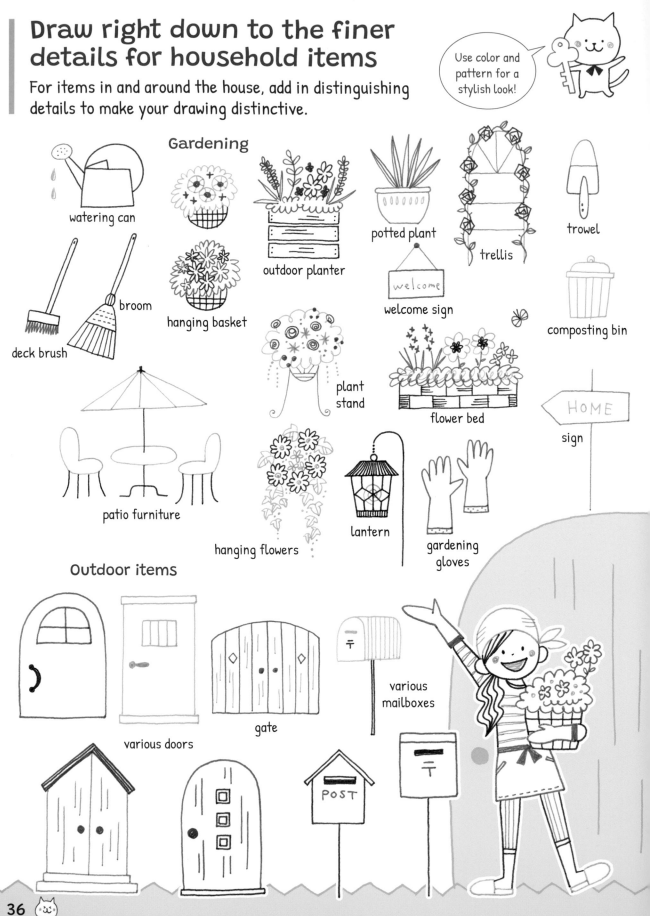

Gardening

watering can

hanging basket

deck brush

broom

outdoor planter

potted plant

trellis

trowel

welcome sign

composting bin

plant stand

flower bed

sign

patio furniture

hanging flowers

lantern

gardening gloves

Outdoor items

various doors

gate

various mailboxes

POST

Interiors

Draw interiors to suit your taste!

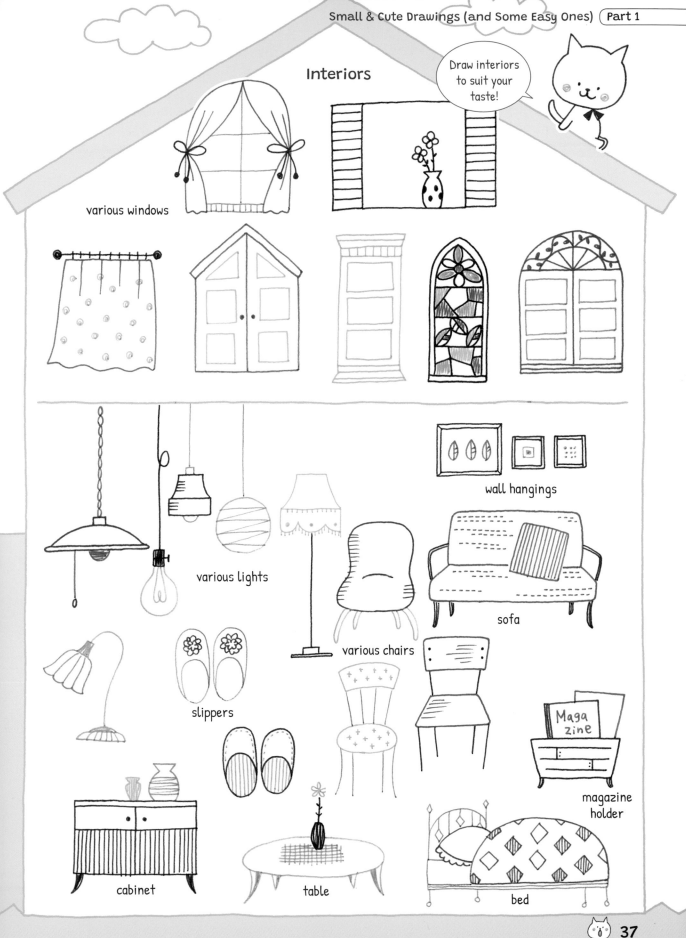

various windows

various lights

wall hangings

sofa

various chairs

slippers

magazine holder

cabinet

table

bed

Tweak simple shapes for vehicles and city structures

Cars, vehicles and buildings can be created by combining shapes such as squares, circles and triangles. It's more important to get the shape right than to fill in the tiny details.

Kids love these!

Flying objects

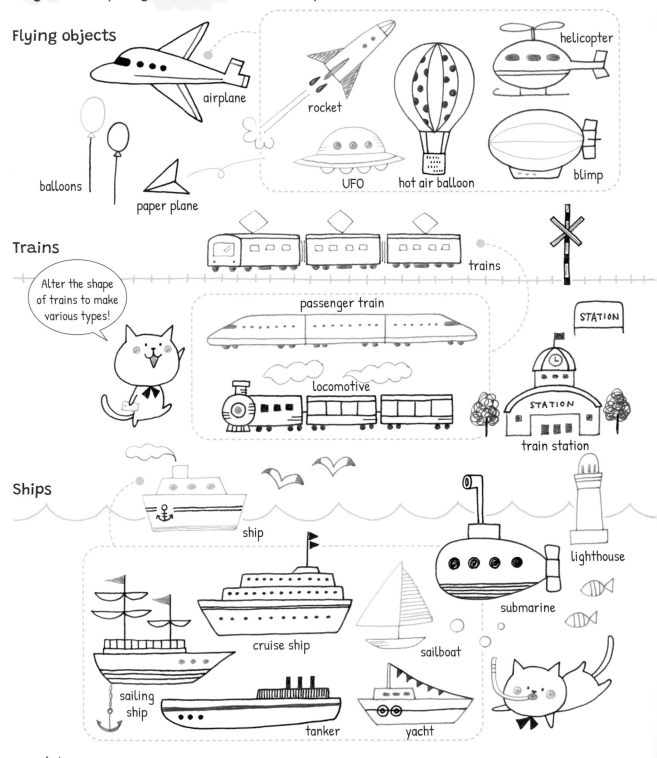

airplane

balloons

paper plane

rocket

UFO

hot air balloon

helicopter

blimp

Trains

Alter the shape of trains to make various types!

trains

passenger train

locomotive

STATION

STATION

train station

Ships

ship

cruise ship

sailboat

sailing ship

tanker

yacht

submarine

lighthouse

Cars

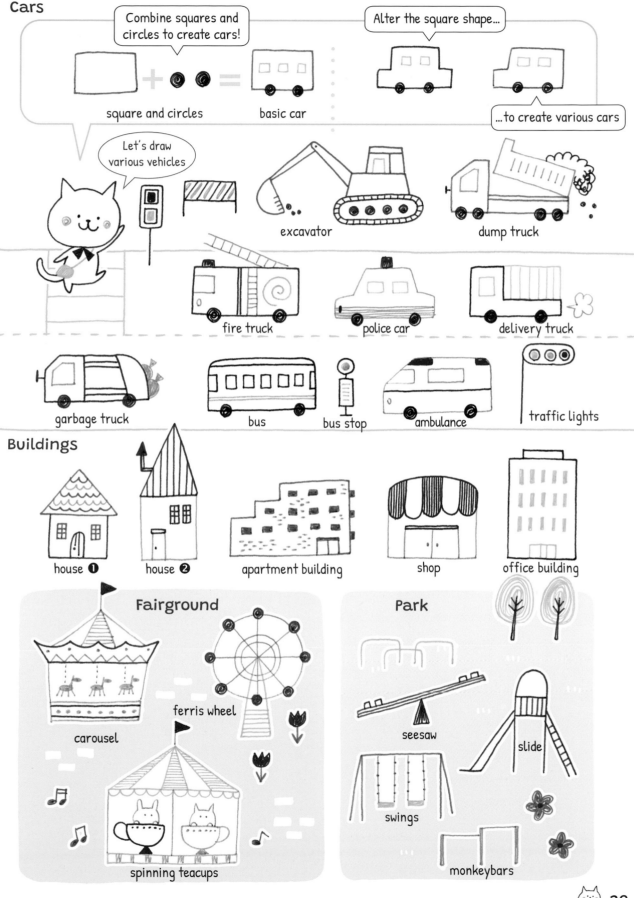

Combine squares and circles to create cars!

square and circles

basic car

Alter the square shape...

...to create various cars

Let's draw various vehicles

excavator

dump truck

fire truck

police car

delivery truck

garbage truck

bus

bus stop

ambulance

traffic lights

Buildings

house ❶

house ❷

apartment building

shop

office building

Fairground

carousel

ferris wheel

spinning teacups

Park

seesaw

swings

slide

monkeybars

Simplify illustrations for school items

Drawings related to school are all of items that are familiar to everyone, so it's fine to make them simple. As long as they resemble the objects in question, your illustration is successful.

Use these drawings for school messages!

Study items

Blue and red are always strong, bold color choices

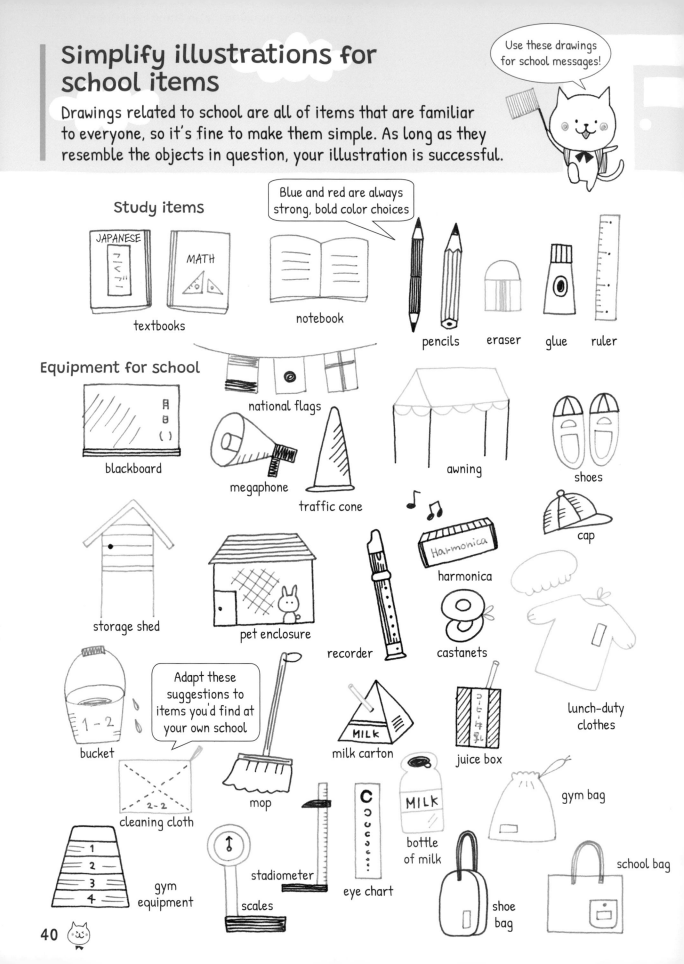

textbooks

notebook

pencils eraser glue ruler

Equipment for school

national flags

blackboard

megaphone

traffic cone

awning

shoes

storage shed

pet enclosure

recorder

harmonica

castanets

cap

lunch-duty clothes

bucket

Adapt these suggestions to items you'd find at your own school

mop

milk carton

juice box

gym bag

cleaning cloth

stadiometer

scales

eye chart

bottle of milk

shoe bag

school bag

gym equipment

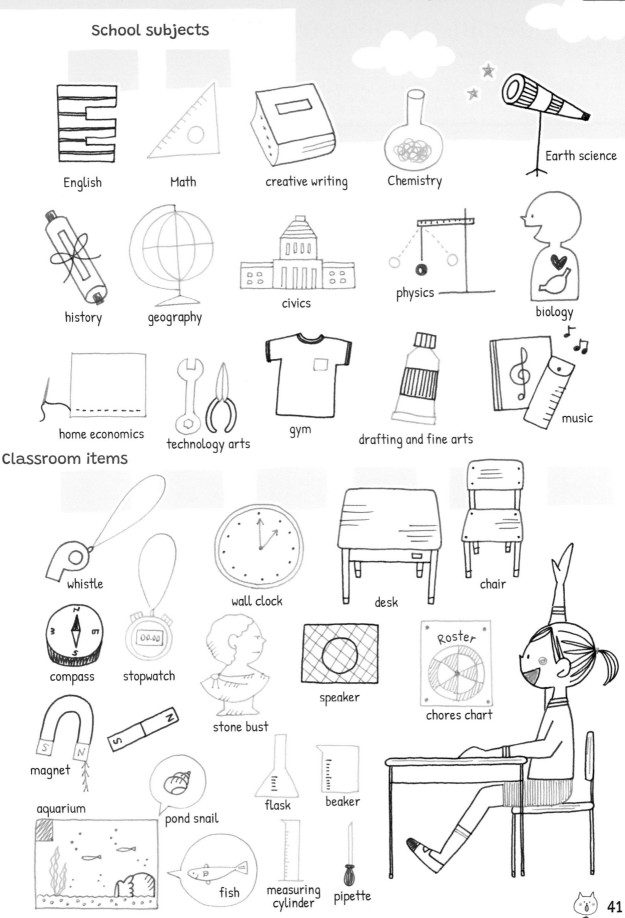

School subjects

English

Math

creative writing

Chemistry

Earth science

history

geography

civics

physics

biology

home economics

technology arts

gym

drafting and fine arts

music

Classroom items

whistle

wall clock

desk

chair

compass

stopwatch

speaker

Roster

chores chart

stone bust

magnet

aquarium

pond snail

flask

beaker

fish

measuring cylinder

pipette

Doll display

Traditional dolls made from drawings are easy both to put on display and to pack away! Make dioramas, seasonal decorations or any home decor item you like to add a personal touch to your interiors.

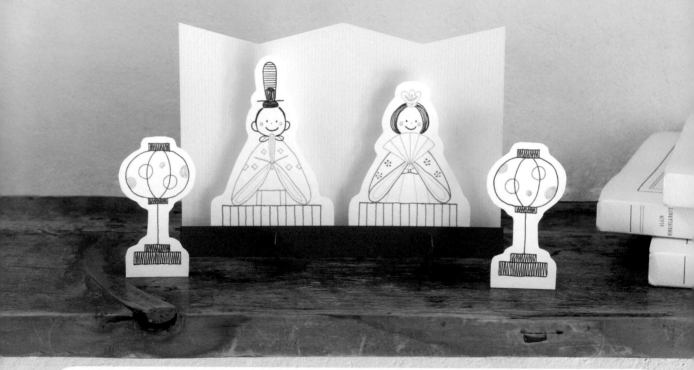

Method

❶ Draw the male and female dolls and cut around them. Stick a long, narrow rectangle of red card to the front of each doll at its base.

❷ Make two slits each in the two short rectangles of red card to be used as the base.

❸ Insert the dolls & base and the folding screen from ❶ into ❷.

❹ Make the paper lanterns stand up and add them to the display.

Slot separate parts into the red base. If it is unstable, increase the number of short rectangles from ❷. Heavy cardstock works best.

Viewed from the side...

Attach another piece of card to the base of the lantern so that it will stand up.

Marine mobile

A mobile swaying gently in the breeze adds style and motion to any room. Use sea-themed illustrations for a summery vibe.

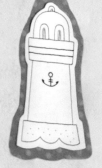

Method

❶ Draw a starfish, yacht, seagull, octopus and lighthouse. Cut them out and stick them onto different colored card.

❷ Punch a hole (3mm diameter) at the top of each piece of card and pass thread through.

❸ Suspend the pieces from two wooden dowels of differing lengths, then use the string to connect the dowels and hang from the ceiling.

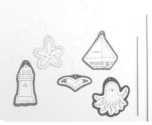

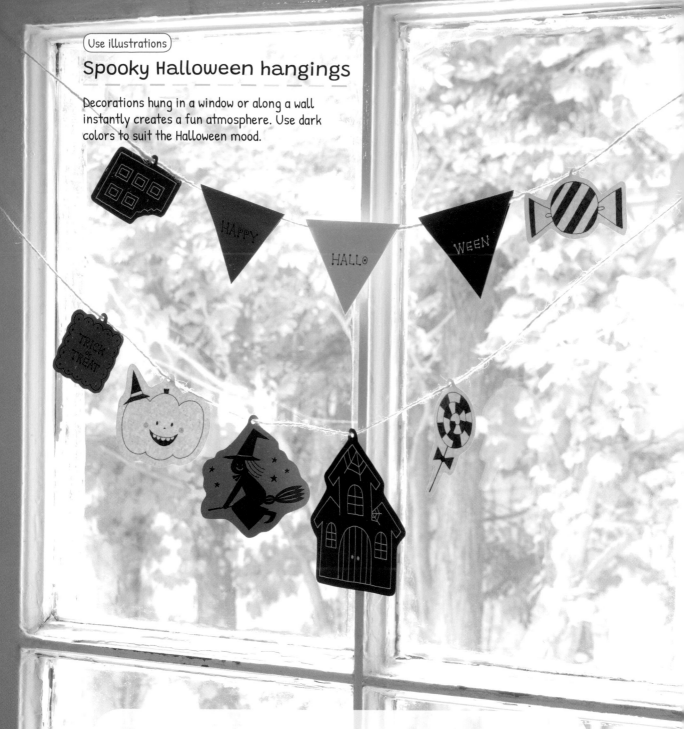

Spooky Halloween hangings

Decorations hung in a window or along a wall instantly creates a fun atmosphere. Use dark colors to suit the Halloween mood.

Method

❶ Draw a pumpkin, candy, witch, house and so on and cut them out. Make a 3mm hole in each piece and pass twine through them. Think about where the holes will be punched before cutting out the illustrations.

❷ Fold diamond-shaped card in half to form a triangle and pass the twine through the folded section. Glue the insides together.

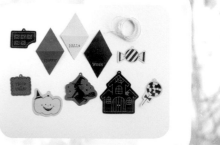

(Use illustrations)

Christmas tree

This little cardboard tree looks cute on a windowsill or bookcase.

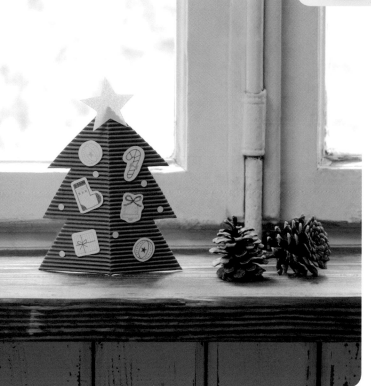

Method

❶ Cut a sheet of green corrugated cardboard into a fir tree shape and fold it in the center so it can stand alone.

❷ Decorate with cut-out drawings of stockings, stars and so on along with stickers.

(Use illustrations)

Snazzy seasonal decorations

A rice cake pops up to offer a seasonal greeting. What sets it apart is that you made it yourself.

Method

❶ Glue a funny or unusual hat to the top of the cutout and affix the decoration to the stand.

❷ Cut a slit into each of the two pieces of card that will form the base and slot the pieces from ❶ in place.

(Use illustrations)

Christmas wreath

With different decorations, this can be used for New Year's festivities as well.

Method

❶ Cut out a donut shape from green corrugated cardboard.

❷ Draw stockings, candy canes and so on, cut them out and stick them to the wreath with glue. Scattering stars around the display makes for a cute touch.

45

Seasonal illustrations

When drawing seasonal happenings or events, the trick is to combine them with the foods, foliage and activities associated with the season.

A sense of the season is important

| Spring | The season of renewal and the conclusion of the school year capture those changes and phases with bright, inviting images. |

Start of the spring term

mortarboard

graduation ceremony

graduation certificate

satchel

ribbon with flower

name badge

school bag

bag for supplies

rain hat

snacktime

kindergarten

school

peony

Use pink scribbles to indicate cherry blossoms. Cut out end of an oval to make a petal.

Jumping for joy: make sure your characters convey their elation at graduating.

Key point for graduation ceremony drawings

Spring events

cycling

Easter bunny

Easter eggs

tree pollen

hay fever

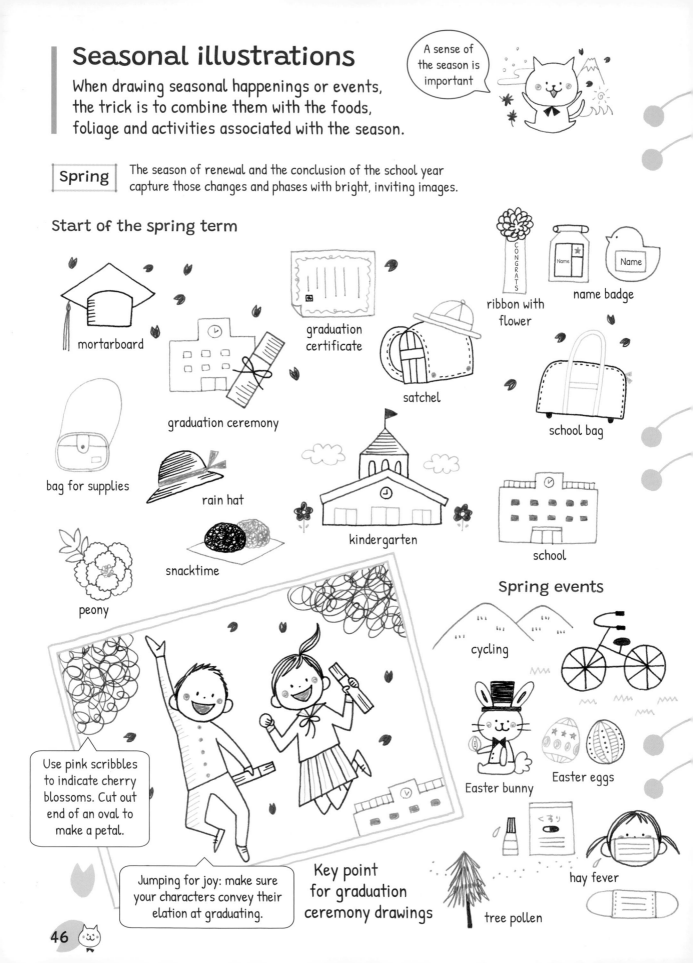

Festivals

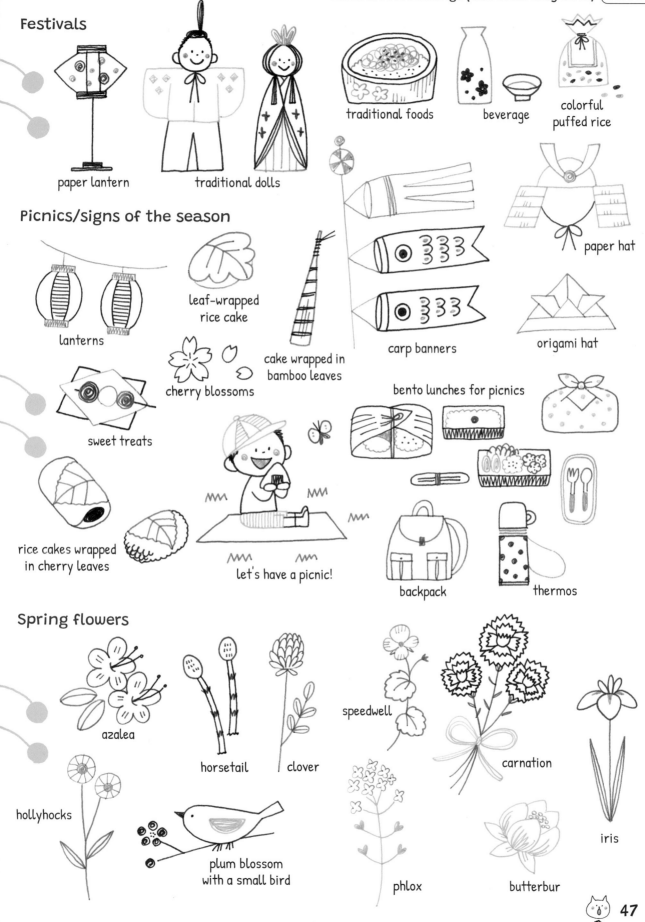

paper lantern

traditional dolls

traditional foods

beverage

colorful puffed rice

Picnics/signs of the season

lanterns

leaf-wrapped rice cake

cake wrapped in bamboo leaves

carp banners

paper hat

origami hat

cherry blossoms

sweet treats

bento lunches for picnics

rice cakes wrapped in cherry leaves

let's have a picnic!

backpack

thermos

Spring flowers

azalea

horsetail

clover

speedwell

carnation

iris

hollyhocks

plum blossom with a small bird

phlox

butterbur

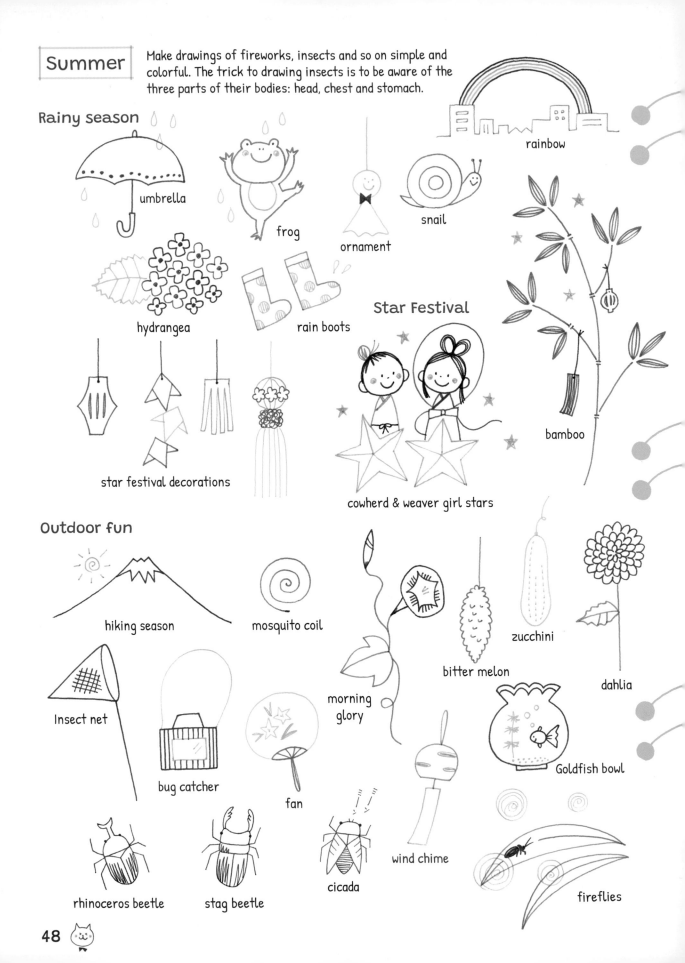

Summer

Make drawings of fireworks, insects and so on simple and colorful. The trick to drawing insects is to be aware of the three parts of their bodies: head, chest and stomach.

Rainy season

umbrella

frog

ornament

snail

rainbow

hydrangea

rain boots

Star Festival

bamboo

star festival decorations

cowherd & weaver girl stars

Outdoor fun

hiking season

mosquito coil

morning glory

bitter melon

zucchini

dahlia

Insect net

bug catcher

fan

cicada

wind chime

Goldfish bowl

rhinoceros beetle

stag beetle

fireflies

48

The sea

shells

snorkelling

crab

flip flops

starfish

rubber ring

Fireworks

fireworks show

Key point for beach illustrations

Use wavy lines to easily make waves, clouds, seagulls and so on!

sparkler

hand-held fireworks

matches

Summer sights

soda

cotton candy

shaved ice

candy apple

4th of July rocket

chocolate-covered banana

grilled corn

water balloon

popsicle

beer

soft serve ice cream

edamame

ghost

summer festival

homework

radio

drawstring bag

sandals

scrapbook

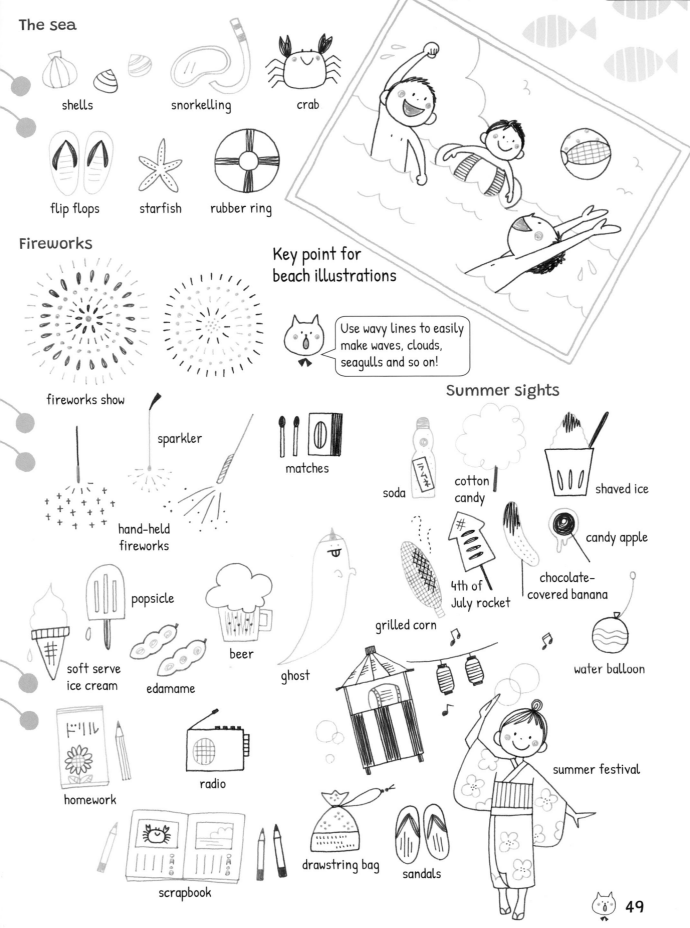

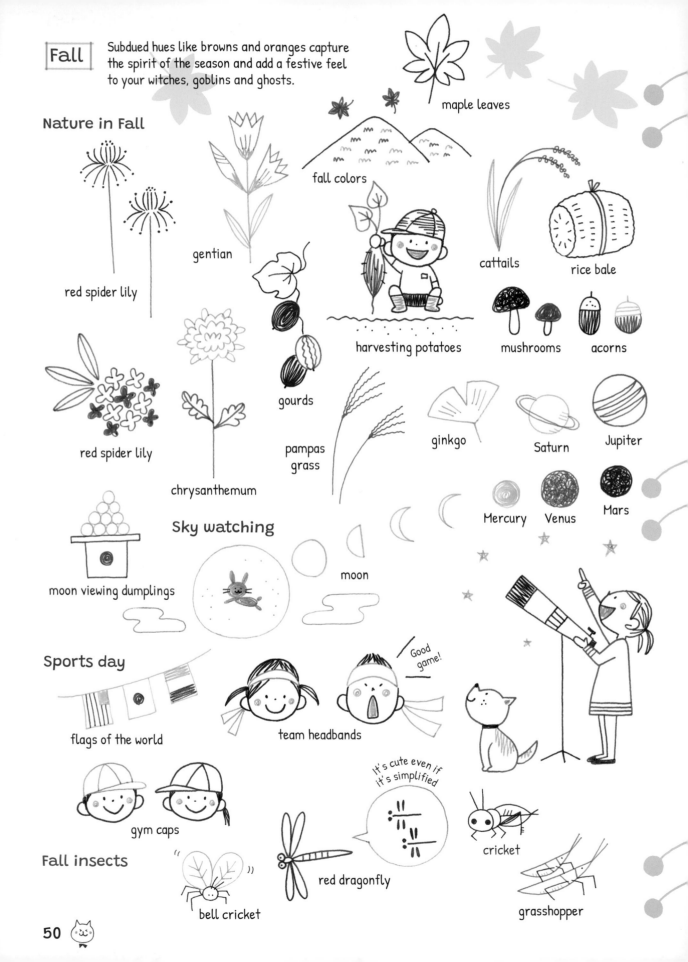

Fall

Subdued hues like browns and oranges capture the spirit of the season and add a festive feel to your witches, goblins and ghosts.

maple leaves

Nature in Fall

red spider lily

gentian

fall colors

harvesting potatoes

cattails

rice bale

mushrooms

acorns

red spider lily

chrysanthemum

gourds

pampas grass

ginkgo

Saturn

Jupiter

Mercury

Venus

Mars

moon viewing dumplings

Sky watching

moon

Sports day

flags of the world

team headbands

Good game!

gym caps

Fall insects

bell cricket

red dragonfly

It's cute even if it's simplified

cricket

grasshopper

Fall festivals

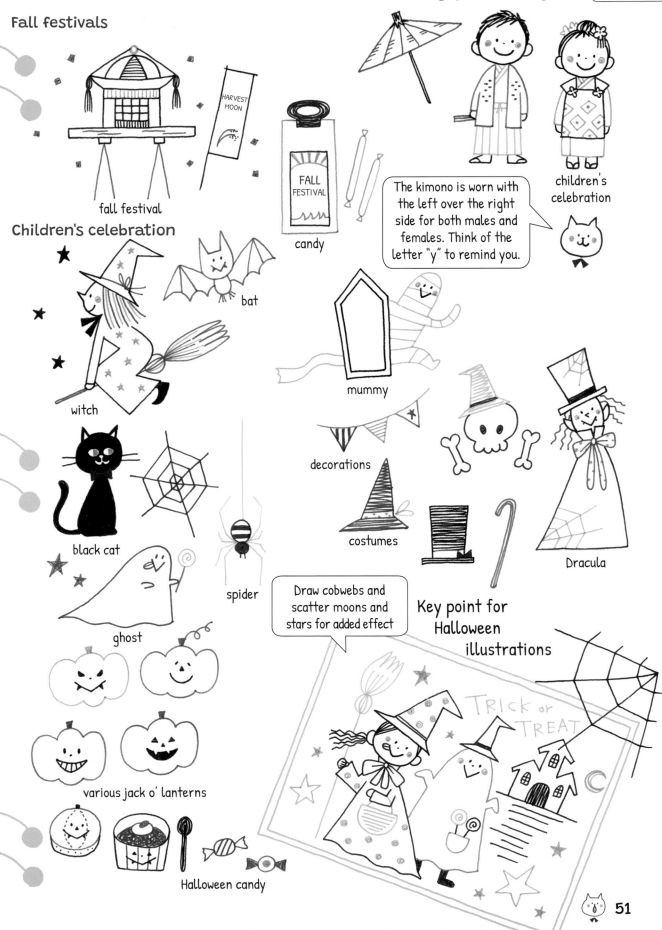

fall festival

HARVEST MOON

FALL FESTIVAL

candy

The kimono is worn with the left over the right side for both males and females. Think of the letter "y" to remind you.

children's celebration

Children's celebration

witch

bat

mummy

decorations

costumes

Dracula

black cat

spider

ghost

Draw cobwebs and scatter moons and stars for added effect

Key point for Halloween illustrations

various jack o' lanterns

Halloween candy

TRICK or TREAT

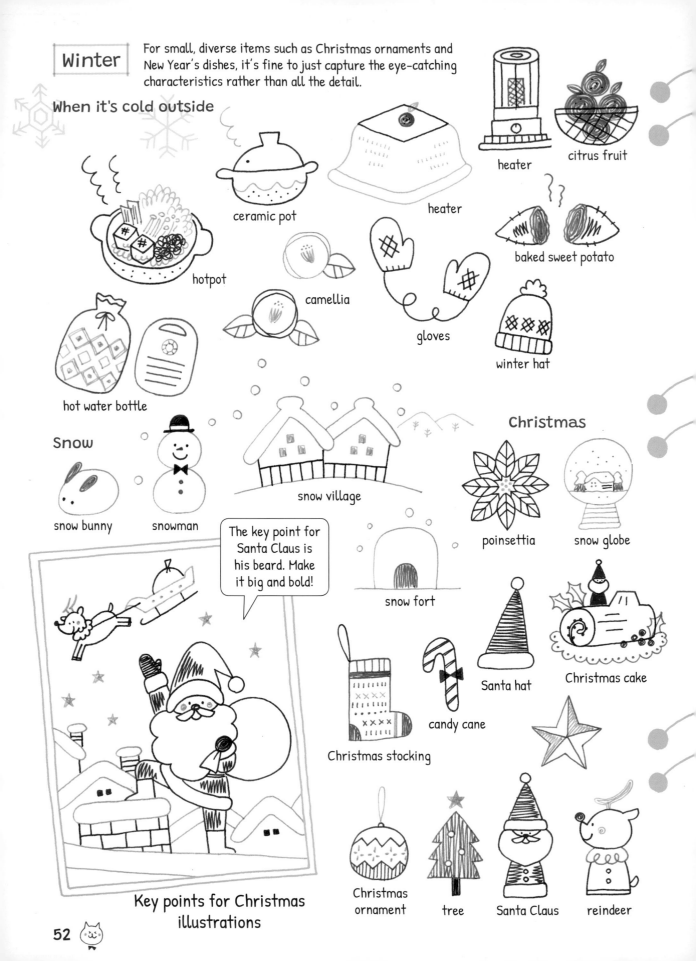

Winter

For small, diverse items such as Christmas ornaments and New Year's dishes, it's fine to just capture the eye-catching characteristics rather than all the detail.

When it's cold outside

heater

citrus fruit

ceramic pot

heater

baked sweet potato

hotpot

camellia

gloves

winter hat

hot water bottle

Snow

snow bunny

snowman

snow village

Christmas

poinsettia

snow globe

The key point for Santa Claus is his beard. Make it big and bold!

snow fort

Santa hat

Christmas cake

Christmas stocking

candy cane

Key points for Christmas illustrations

Christmas ornament

tree

Santa Claus

reindeer

New Year

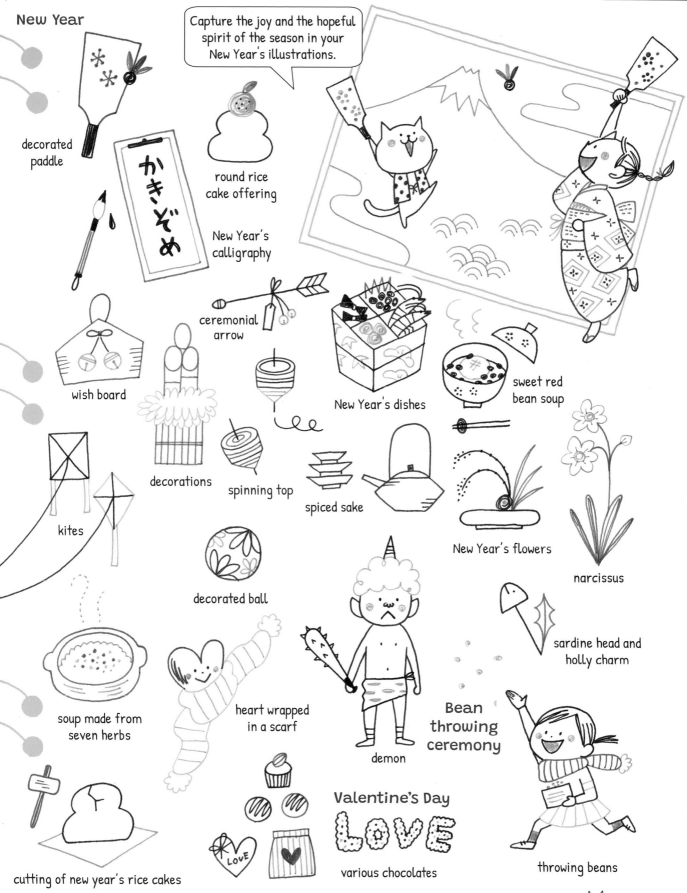

Capture the joy and the hopeful spirit of the season in your New Year's illustrations.

decorated paddle

round rice cake offering

New Year's calligraphy

かきぞめ

ceremonial arrow

wish board

decorations

spinning top

New Year's dishes

sweet red bean soup

spiced sake

New Year's flowers

narcissus

kites

decorated ball

soup made from seven herbs

heart wrapped in a scarf

demon

Bean throwing ceremony

sardine head and holly charm

cutting of new year's rice cakes

Valentine's Day

LOVE

various chocolates

throwing beans

53

Handy symbols from the western and eastern Zodiac

Make them simple

If you can draw various zodiac symbols, you'll never be at a loss as to what to draw on birthday cards, yearly greetings and so on. Learn how to draw the characteristic parts of the animals and other symbols.

| Zodiac | Make the symbols using animals, humans and so on extremely simple. Adding a star is the finishing touch for these astrological signs. |

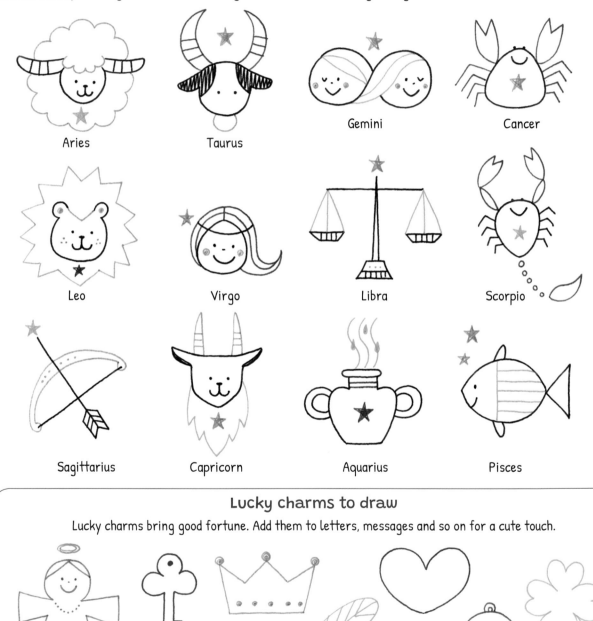

Aries

Taurus

Gemini

Cancer

Leo

Virgo

Libra

Scorpio

Sagittarius

Capricorn

Aquarius

Pisces

Lucky charms to draw

Lucky charms bring good fortune. Add them to letters, messages and so on for a cute touch.

angel

key

crown

feather

heart

bell

four leaf clover

Japanese zodiac

Start by practicing animals' basic faces. Once you have a feel for it, add your own touches for original looks.

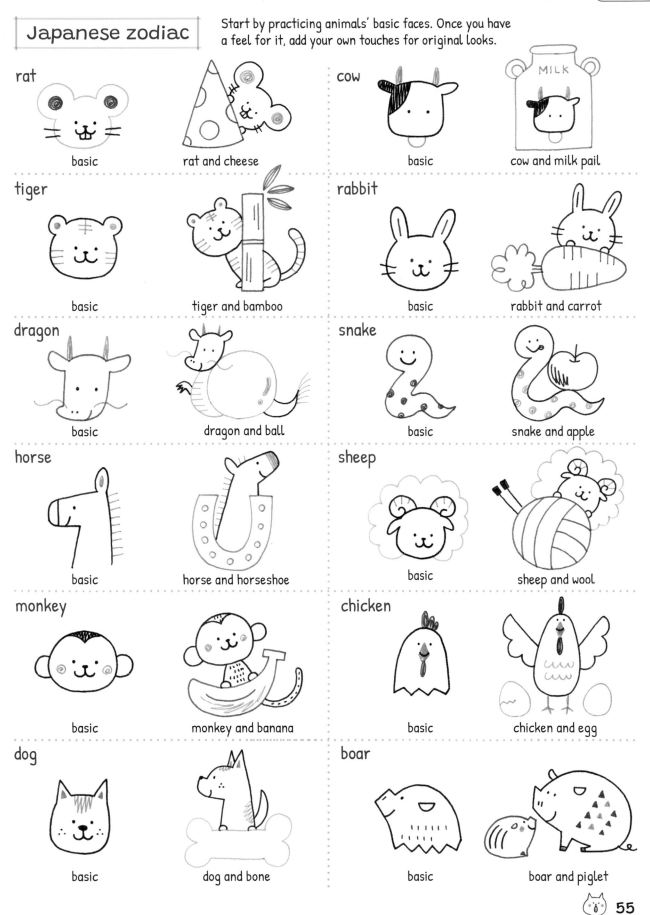

rat
basic
rat and cheese

cow
basic
cow and milk pail

tiger
basic
tiger and bamboo

rabbit
basic
rabbit and carrot

dragon
basic
dragon and ball

snake
basic
snake and apple

horse
basic
horse and horseshoe

sheep
basic
sheep and wool

monkey
basic
monkey and banana

chicken
basic
chicken and egg

dog
basic
dog and bone

boar
basic
boar and piglet

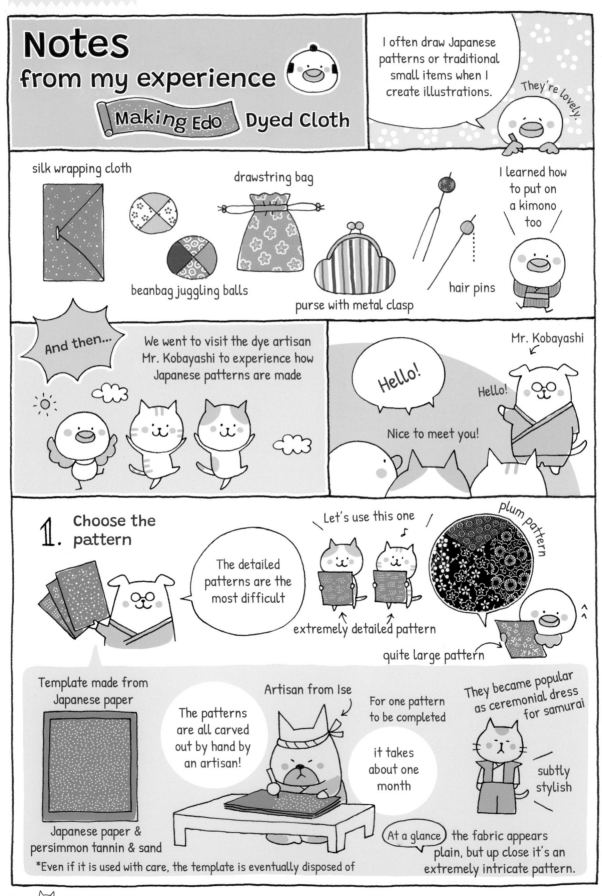

Notes from my experience
Making Edo Dyed Cloth

I often draw Japanese patterns or traditional small items when I create illustrations.

They're lovely.

silk wrapping cloth

beanbag juggling balls

drawstring bag

purse with metal clasp

hair pins

I learned how to put on a kimono too

And then...

We went to visit the dye artisan Mr. Kobayashi to experience how Japanese patterns are made

Hello!

Nice to meet you!

Hello!

Mr. Kobayashi

1. Choose the pattern

The detailed patterns are the most difficult

Let's use this one

extremely detailed pattern

plum pattern

quite large pattern

Template made from Japanese paper

The patterns are all carved out by hand by an artisan!

Artisan from Ise

For one pattern to be completed

it takes about one month

They became popular as ceremonial dress for samurai

subtly stylish

Japanese paper & persimmon tannin & sand

*Even if it is used with care, the template is eventually disposed of

At a glance the fabric appears plain, but up close it's an extremely intricate pattern.

2. Stretch the silk fabric on a board and the template over the top

It's quite difficult to get the fabric straight

template

↑ The board is a 23-foot (7-m) piece of fir.

3. Spread paste over the template

It's also tricky to get the paste spread evenly so there are no gaps

Those artisans are something else!

The paste is made from glutinous rice, rice bran, salt and activated charcoal

In the Edo period, artisans from Kansai used a board while artisans from Kanto used a spatula.

I'm from Kansai

I'm from Kanto

Here, we're using a board

4. Remove the template and apply dyestuff once paste is dry

Diagram of cross section

dyestuff

paste

fabric

board

Now I get it

The editor who came with me was so good that she was told she could be an artisan! Wow

The colors are a secret blend

Once the paste is dissolved, the pattern appears in white

exciting!

5. Steam

So much steam! It would be good for your skin

wait 23 minutes

Spread sawdust on the fabric and hang the pieces so they don't touch

The patterns have meanings!

6. Wash

Wave the fabric in the water quite vigorously. It's fun to see the pattern slowly emerging!

7. Dry to complete

In the olden days, you could tell what the trends were by looking at the patterns on the fabric hanging out to dry

Various facts about patterns

Hemp leaves

Hemp grows fast so it is used for clothes for babies.

Arrows

Since the Edo period, this has been an auspicious pattern as an arrow does not return once it is shot.

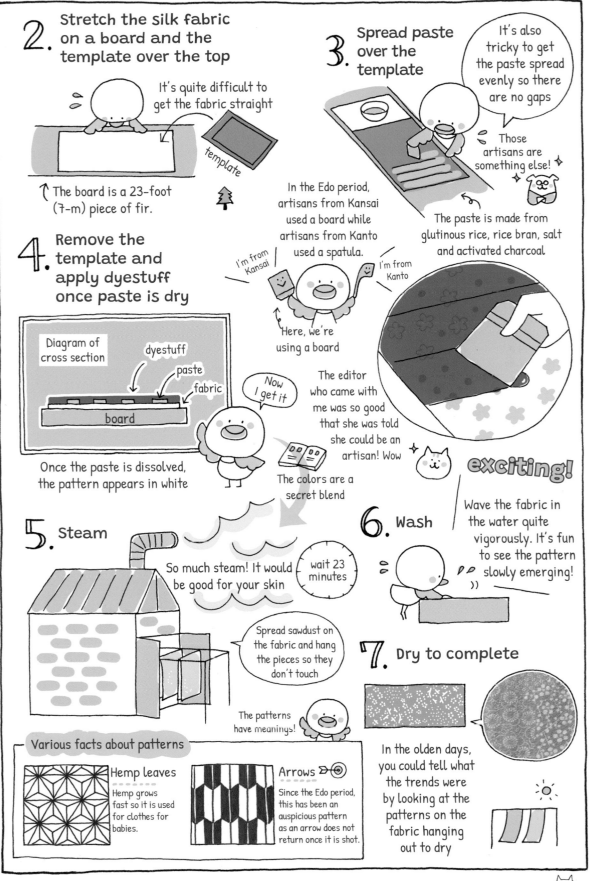

Characters & Icons with All Kinds of Uses

It's handy being able to draw animal characters and icons for events and celebrations. They'll brighten up whatever you add them to.

Use illustrations

Stickers

Add hand-drawn illustrations to make original stickers from plain, store-bought ones. Add fun or funny messages to them, then cut them out to the shape of the illustration.

Sticky notes

Try adding drawings of characters to reminder notes, requests, thank you notes and so on to bring fun touches to admin-type messages.

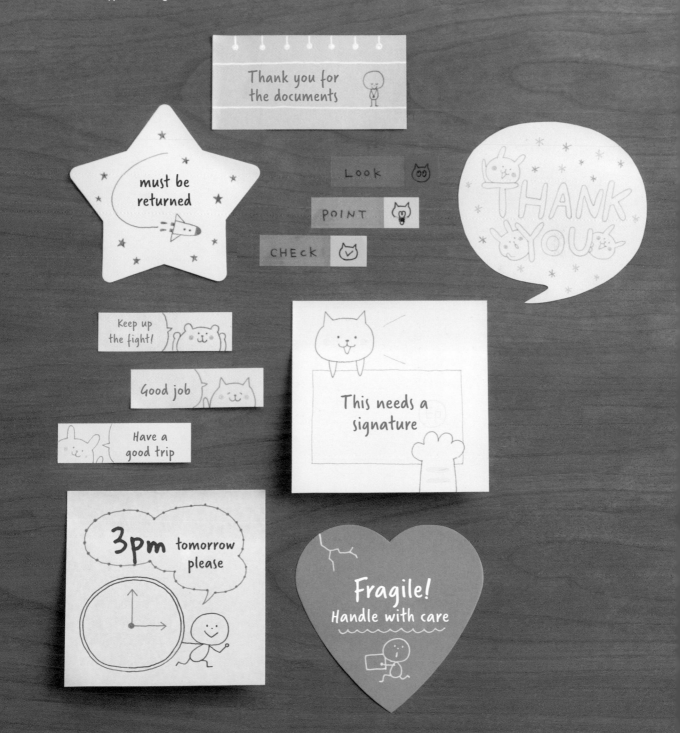

Thank you for the documents

must be returned

LOOK

POINT

CHECK

THANK YOU

Keep up the fight!

Good job

Have a good trip

This needs a signature

3pm tomorrow please

Fragile!
Handle with care

Express characters' emotions with humor

Characters play a huge role in accurately conveying feelings or situations. First of all, master how to draw poses using a simplified human figure.

Isn't this fun?

Using circles and lines to draw poses

Try adjusting the movement of the joints, the facial expression and so on. Even a simplified human figure can express various emotions.

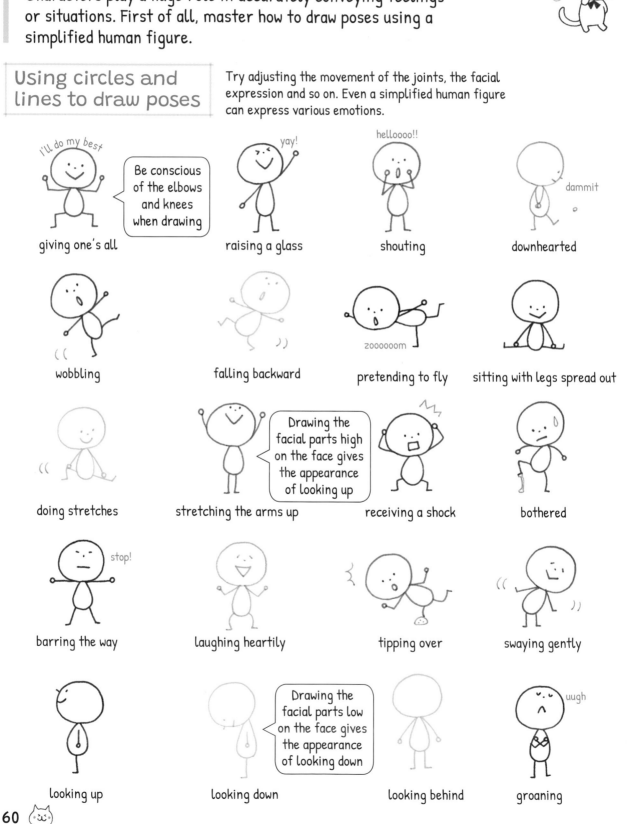

I'll do my best

Be conscious of the elbows and knees when drawing

giving one's all

yay!

raising a glass

helloooo!!

shouting

dammit

downhearted

wobbling

falling backward

zoooooom

pretending to fly

sitting with legs spread out

doing stretches

Drawing the facial parts high on the face gives the appearance of looking up

stretching the arms up

receiving a shock

bothered

stop!

barring the way

laughing heartily

tipping over

swaying gently

looking up

Drawing the facial parts low on the face gives the appearance of looking down

looking down

looking behind

uugh

groaning

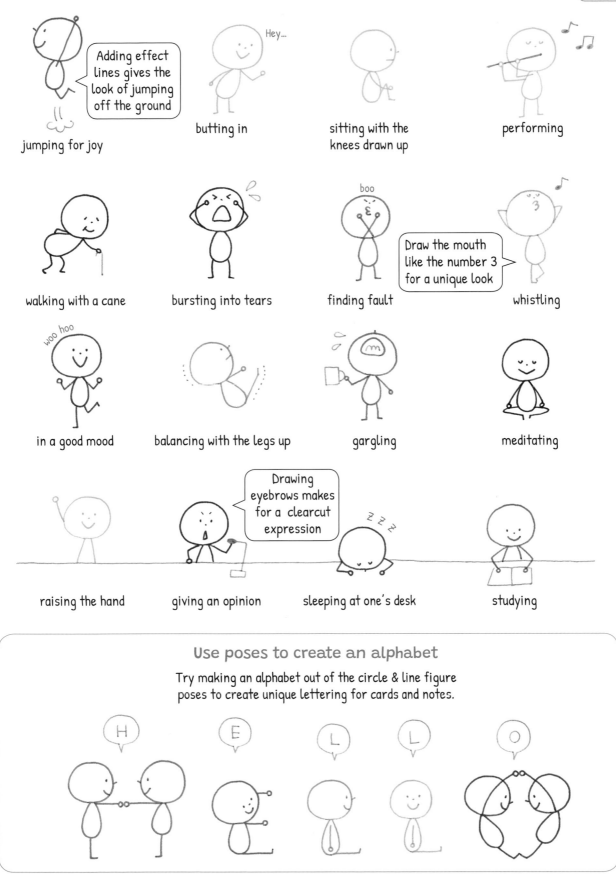

jumping for joy

butting in

sitting with the knees drawn up

performing

walking with a cane

bursting into tears

finding fault

whistling

in a good mood

balancing with the legs up

gargling

meditating

raising the hand

giving an opinion

sleeping at one's desk

studying

Use poses to create an alphabet

Try making an alphabet out of the circle & line figure poses to create unique lettering for cards and notes.

Illustrations for messages using cats

Their flexible bodies make cats an easy animal to use as a character. Giving them human-like movements and expressions creates fun results.

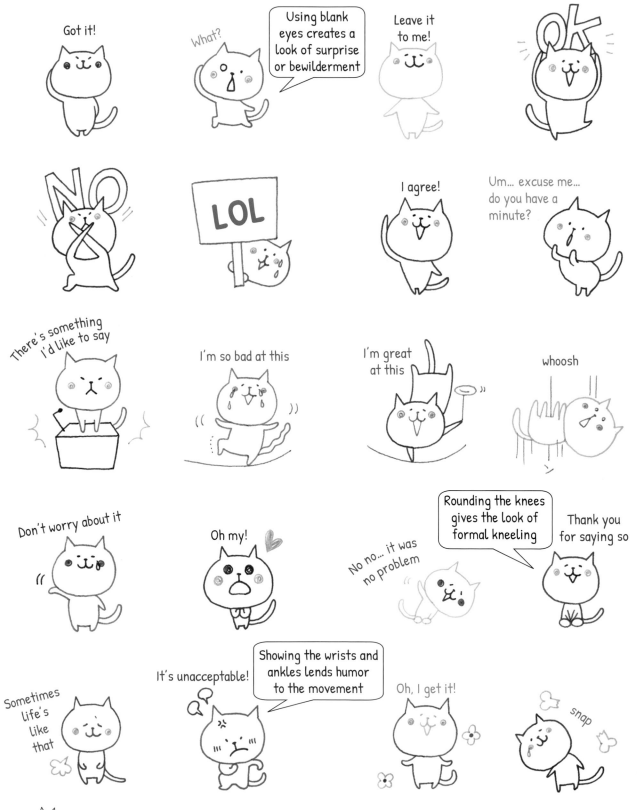

Got it!

What?

Using blank eyes creates a look of surprise or bewilderment

Leave it to me!

OK

NO

LOL

I agree!

Um... excuse me... do you have a minute?

There's something I'd like to say

I'm so bad at this

I'm great at this

whoosh

Don't worry about it

Oh my!

No no... it was no problem

Rounding the knees gives the look of formal kneeling

Thank you for saying so

Sometimes life's like that

It's unacceptable!

Showing the wrists and ankles lends humor to the movement

Oh, I get it!

snap

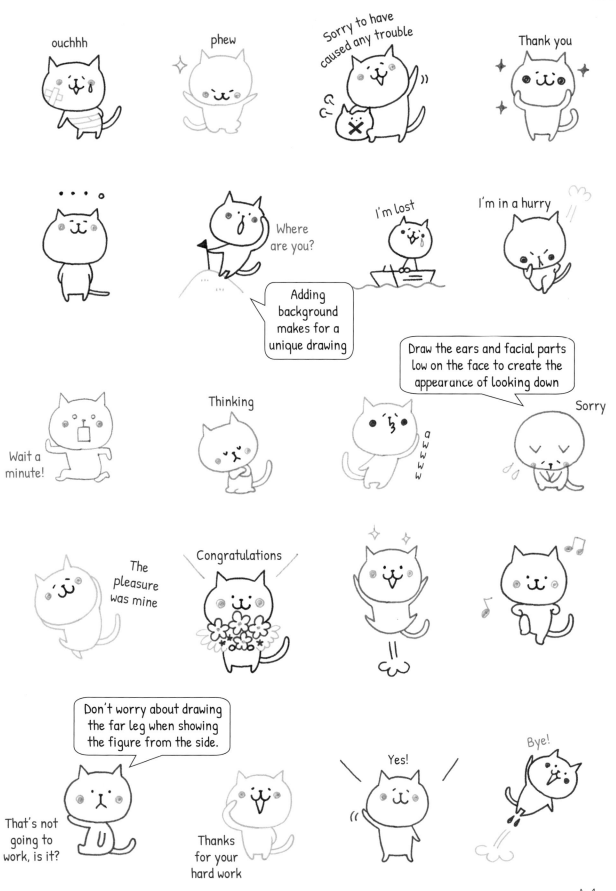

Illustrations for messages using dogs

Slightly altering the ears of the cat figure turns the character into a dog. Try using the ears and tail to express emotion also.

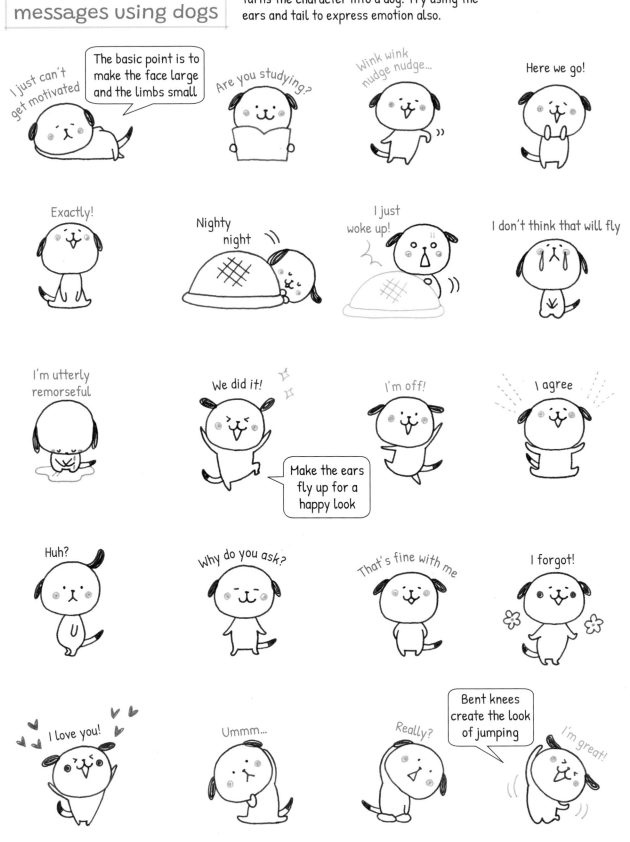

I just can't get motivated

The basic point is to make the face large and the limbs small

Are you studying?

Wink wink nudge nudge...

Here we go!

Exactly!

Nighty night

I just woke up!

I don't think that will fly

I'm utterly remorseful

We did it!

Make the ears fly up for a happy look

I'm off!

I agree

Huh?

Why do you ask?

That's fine with me

I forgot!

I love you!

Ummm...

Really?

Bent knees create the look of jumping

I'm great!

Illustrations for messages using rabbits and bears

Try using your favorite animals or animals that resemble you in your drawings. You'll have even more fun when you can draw your own characters!

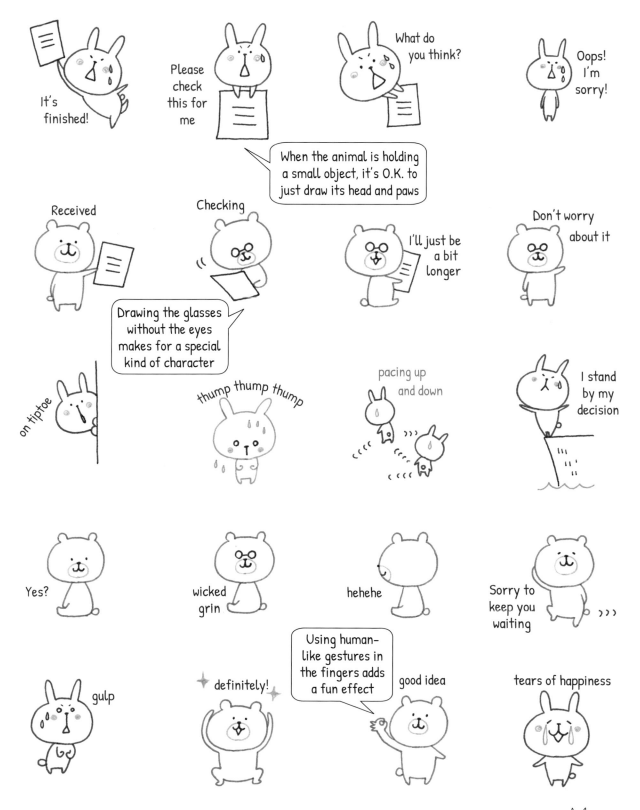

It's finished!

Please check this for me

What do you think?

Oops! I'm sorry!

When the animal is holding a small object, it's O.K. to just draw its head and paws

Received

Checking

I'll just be a bit longer

Don't worry about it

Drawing the glasses without the eyes makes for a special kind of character

on tiptoe

thump thump thump

pacing up and down

I stand by my decision

Yes?

wicked grin

hehehe

Sorry to keep you waiting

Using human-like gestures in the fingers adds a fun effect

gulp

definitely!

good idea

tears of happiness

Planners

Using simple icons for everyday plans and special events makes every time you open your planner enjoyable. There's the added bonus that you'll be able to see at a glance what's on your schedule.

Maps

When explaining to someone how to get to your house or to a meeting point, it's handy to be able to draw a map. Learn how to draw simple buildings and landmarks.

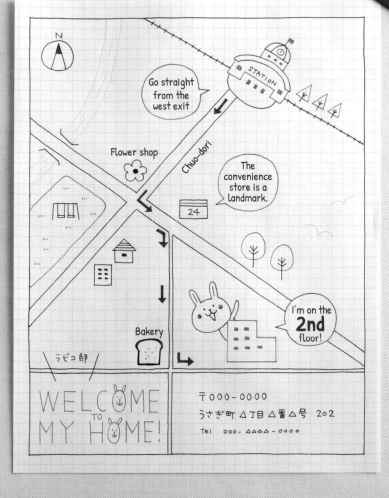

Make icons simple and concise

For icons to use in planners, memos and so on, keep them simple, small and easy to draw. See what you come up with!

It's easier to read

Weather	It's handy to have icons for weather for journals, diaries and calendars. Icons are helpful for capturing subtleties in the weather too.

rain

light rain fine weather

cloud

partly cloudy

thunder & lightning

gusts of wind

heavy rain

scattered showers

snow heavy snow

hail fog

Keep the handle in the center of the umbrella for a balanced picture

typhoon tornado rainbow

Even if the cat's in a raincoat, don't forget the tail!

Key points for drawing rainy days

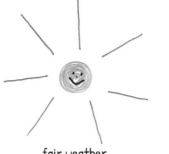

fair weather

partly sunny

chance of rain

a good drying day

first breeze of spring

cherry blossom front

pollen alert

hydration

midsummer sun

peak of summer

UV protection ❶

UV protection ❷

bare trees

Indian summer

take care In
the dry air ❶

take care in
the dry air ❷

guard against colds

guard against influenza

I recorded the top
temperature

I recorded the lowest
temperature

cold wave

earthquake

heat wave

air pollution

Hobbies

Hobby-related objects and equipment, such as musical instruments, cameras and art supplies, are often unique in shape, so try to capture their characteristics to create evocative icons.

painting

taking photos

travel

watching movies

tea ceremony

flower arranging

crafts

calligraphy

fishing

aromatherapy

watching sports

Japanese chess

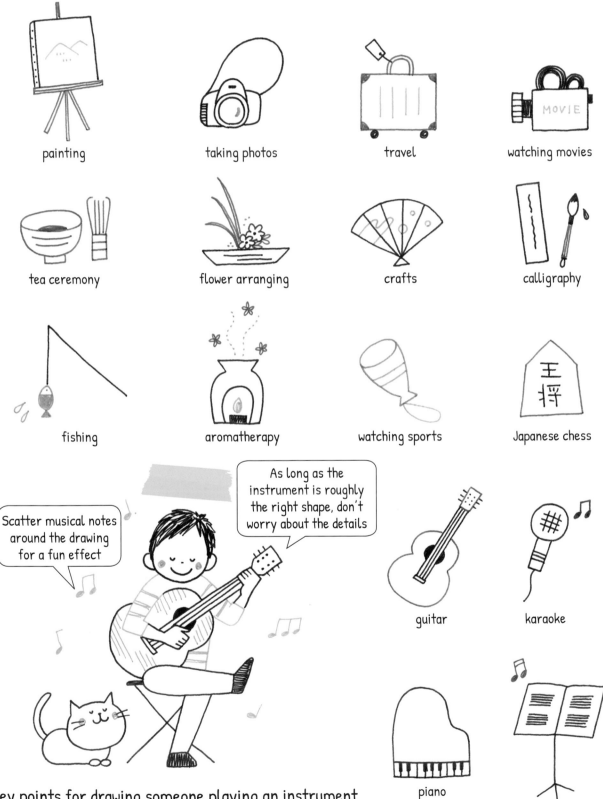

Scatter musical notes around the drawing for a fun effect

As long as the instrument is roughly the right shape, don't worry about the details

guitar

karaoke

Key points for drawing someone playing an instrument

piano

choir

Sports

Make equipment simple when drawing icons for sports. In particular, as long as you draw the right pattern inside a circle, you can draw various balls.

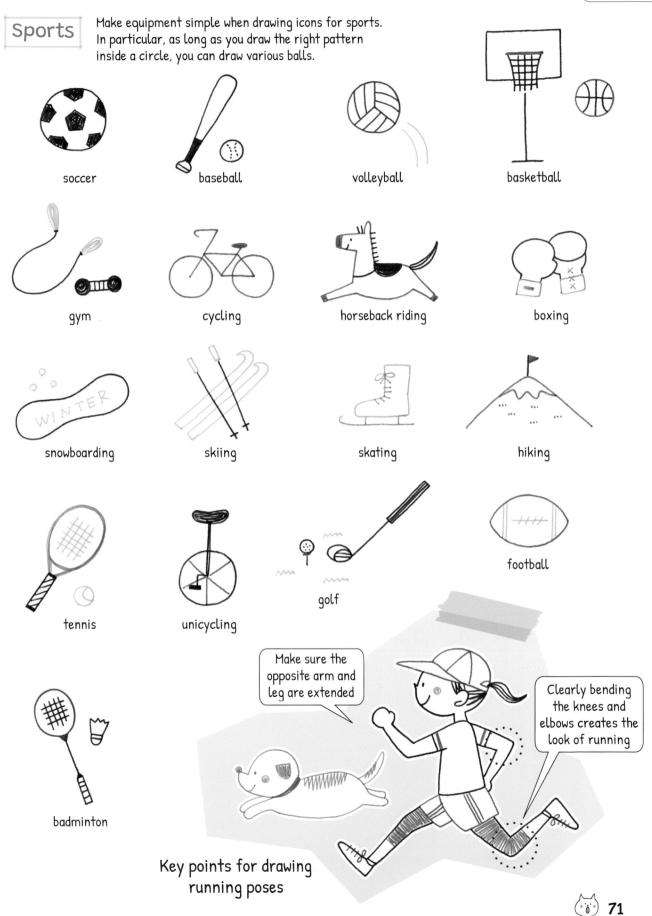

soccer

baseball

volleyball

basketball

gym

cycling

horseback riding

boxing

snowboarding

WINTER

skiing

skating

hiking

tennis

unicycling

golf

football

badminton

Make sure the opposite arm and leg are extended

Clearly bending the knees and elbows creates the look of running

Key points for drawing running poses

71

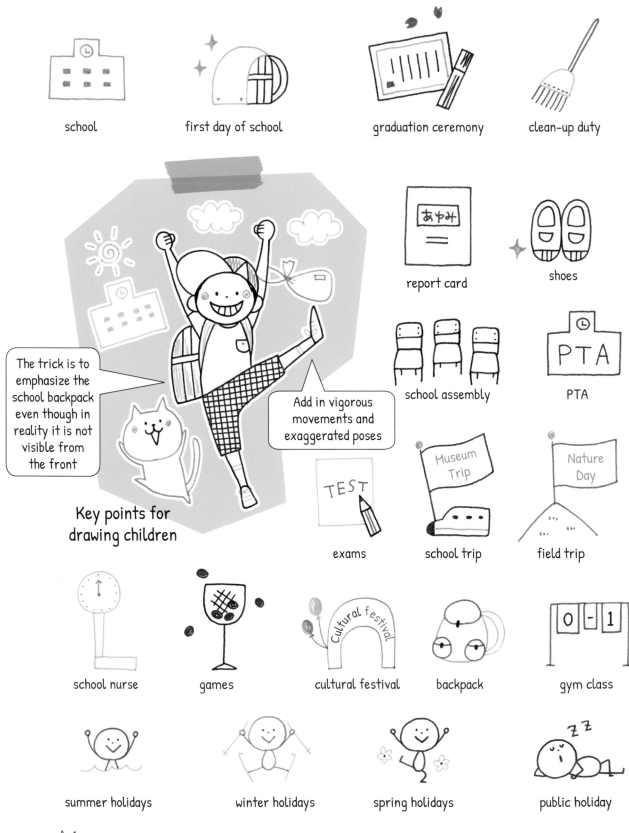

School

The trick is to draw school-related items in a simple way.
Also see pages 40–41 for other things found at school.

school

first day of school

graduation ceremony

clean-up duty

report card

shoes

The trick is to emphasize the school backpack even though in reality it is not visible from the front

school assembly

PTA

Add in vigorous movements and exaggerated poses

Key points for drawing children

exams

school trip

field trip

school nurse

games

cultural festival

backpack

gym class

summer holidays

winter holidays

spring holidays

public holiday

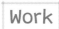 Work

For icons related to work, as long as you can understand them, anything goes! Make them super simple so you can draw them quickly.

email

telephone

half day off

whole day off

→ NYC
work trip

overseas work trip

5/22
deadline day

meeting
meeting

Direct to ___
direct to ___

Going straight home
going straight home

PC being repaired

delivery service

search for documents

creating documents

15:00
Presentation
presentation

PASSED
seal

sales (external)

overtime

Holding documents helps suggest an office worker. Sticky notes are good too.

early shift

late shift

night shift

socializing with co-workers

For the right balance, make sure the feet don't point inward.

Key points for drawing a company employee

73

Special events

Use plenty of color to brighten up enjoyable events and plans. Make them even more fun by adding sparkle effects!

wedding anniversary

wedding day

Children's celebration

reunion

祭

festival

fireworks

cherry blossom festival

picnic

=3

moving day

house party

dinner party

visiting hometown

Birthdays

Birthday cake

Birthday hat

present ❶

present ❷

streamers

decorations

The shape of the mouth when blowing out candles is key

Put the birthday person and cake in the very middle!

Key points for birthday illustrations

Everyday activities

For appointments, returning items, payment days, days you need to take your lunch and so on, it's handy to be able to use icons as reminders.

supermarket

department store

garbage day

recyclables day

water bill is due

electric bill is due

meal

date

Fill in the return date
library

bank

post office

government building

doctor ❶

doctor ❷

pay day

payment due

pack a lunch

drinks after work

Monthly fee
monthly fee

CARD
credit card payment

hairdresser

dry cleaning

dog grooming

vet

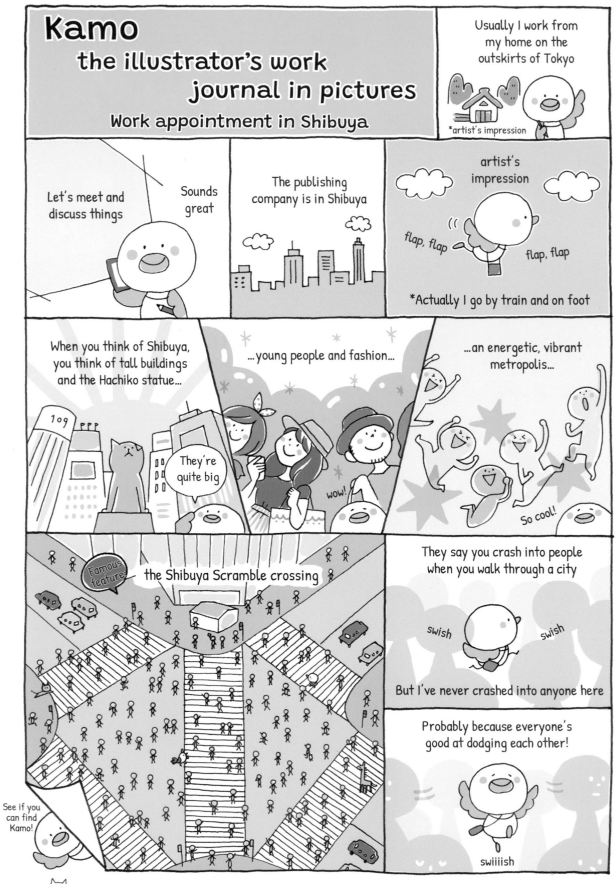

Kamo
the illustrator's work journal in pictures
Work appointment in Shibuya

Usually I work from my home on the outskirts of Tokyo

*artist's impression

Let's meet and discuss things

Sounds great

The publishing company is in Shibuya

artiist's impression

flap, flap

flap, flap

*Actually I go by train and on foot

When you think of Shibuya, you think of tall buildings and the Hachiko statue...

...young people and fashion...

...an energetic, vibrant metropolis...

They're quite big

wow!

So cool!

Famous feature:

the Shibuya Scramble crossing

They say you crash into people when you walk through a city

swish

swish

But I've never crashed into anyone here

Probably because everyone's good at dodging each other!

swiiiish

See if you can find Kamo!

76

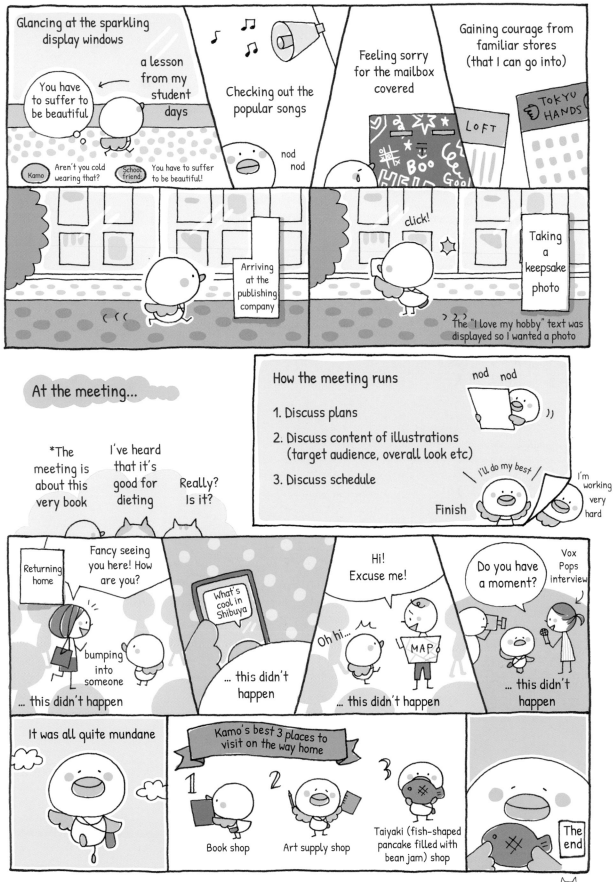

Making Cards and Notes Using Decorative Lettering

Here, we look at designs for business cards, postcards, and other cards that incorporate decorative lettering. It's handy to master decorative lettering.

(Use illustrations)

Business cards

A business card determines the kind of first impression you make. Use illustrations to good effect to promote yourself! Try using the back, folding the card in half.

ノハラ ハナ

School: N Girls' School

My Favorite
Food: grapes
Animal: Dog

Nice to meet you!

On the back...

Draw something you like or make cute decorations for a memorable business card.

illustrator
青井 すず

Email:

Tel:

Fax:

@SHIORI

Or opened up...

This design resembles a book. A folded business card is handy when introducing yourself or publicizing an event.

はじめまして
野原 花
です

mail : hana@△△△.net

森野ことり・ひなこ
こトリママ
morinotori @ △△△△.com

@ Shiori

✉ shiori@△△.com

TEL 000-△△△△-0000

Hobbies: reading

I run a book club on the second Saturday of every month

At N Café

See page 81 for instructions

Notes of appreciation and celebration

For birthdays, weddings, births and other celebrations or for messages of thanks, use bright color schemes and celebratory illustrations in your designs.

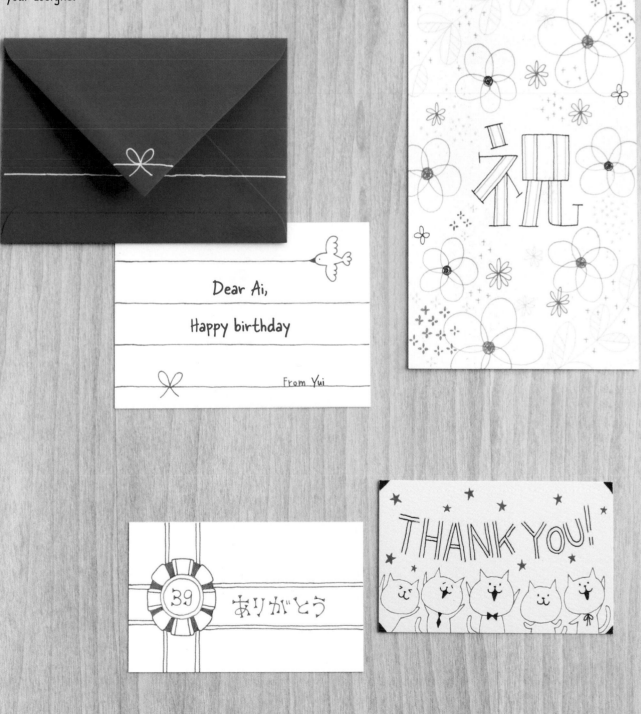

Invitations

For event invitations, alter the shape of the card to delight the recipient. Add a cute fork when sending a card in the shape of a cake.

BIRTHDAY PARTY!

Date
Time
Place: My house
Address

Looking forward to seeing you! ♥

See page 81 for instructions

Place it in the envelope...

Folding a fan-shaped piece of paper creates a card resembling a piece of cake. Put it into a semi-transparent envelope to make it seem as if a cake is inside.

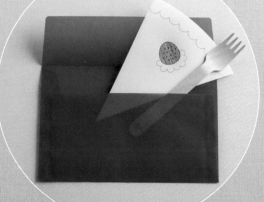

How to create a book-shaped business card (page 78)

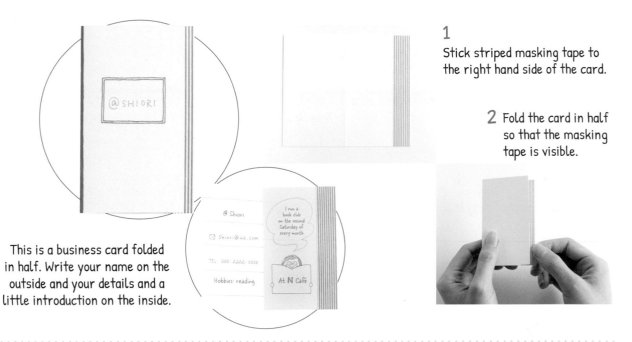

This is a business card folded in half. Write your name on the outside and your details and a little introduction on the inside.

1 Stick striped masking tape to the right hand side of the card.

2 Fold the card in half so that the masking tape is visible.

How to create a cake-shaped invitation (page 80)

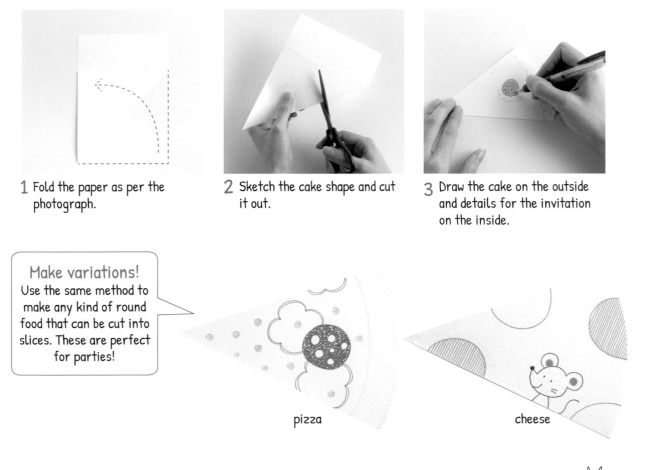

1 Fold the paper as per the photograph.

2 Sketch the cake shape and cut it out.

3 Draw the cake on the outside and details for the invitation on the inside.

Make variations!
Use the same method to make any kind of round food that can be cut into slices. These are perfect for parties!

pizza

cheese

Learn the principles for decorative lettering

Once you learn the simple principles, you can create cute lettering that will instantly dress up notes and cards.

Make sure to master this!

Hiragana — Here, we look at an approach known as thick verticals & short bars, a style where the vertical lines are thickened and short lines or bars are placed at the ends of lines.

Thick verticals & short bars

Partially draw the あ character. → Thicken the vertical line → Draw the remainder, thickening the curved section and adding short bars at the ends of lines

50 characters

Thicken the areas that are basically vertical

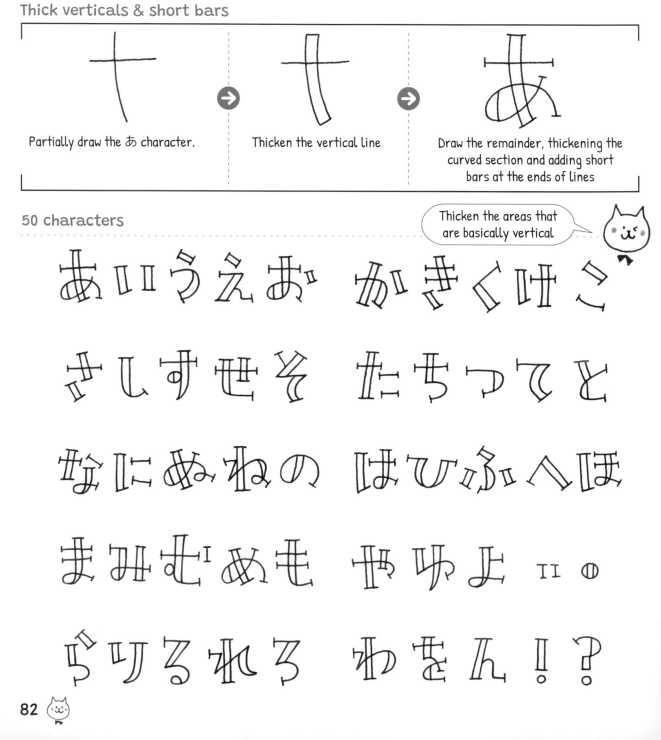

Let's try variations on the basic font

Once you can make characters in the thick verticals & short bars style, try altering them to make various types of characters.

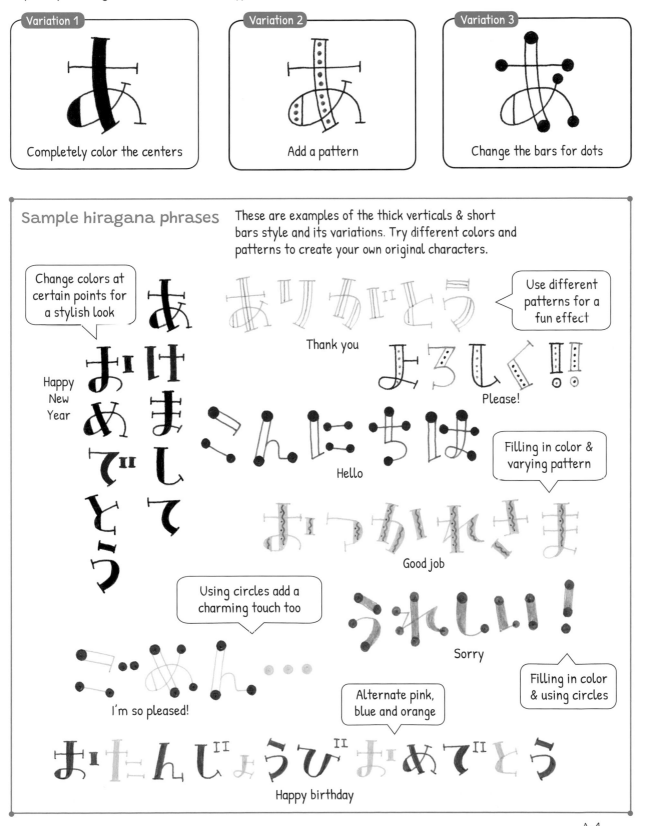

Variation 1

Completely color the centers

Variation 2

Add a pattern

Variation 3

Change the bars for dots

Sample hiragana phrases

These are examples of the thick verticals & short bars style and its variations. Try different colors and patterns to create your own original characters.

Change colors at certain points for a stylish look

Use different patterns for a fun effect

Thank you

Please!

Happy New Year

Hello

Filling in color & varying pattern

Good job

Using circles add a charming touch too

Sorry

Filling in color & using circles

I'm so pleased!

Alternate pink, blue and orange

Happy birthday

Katakana

Adding circles to the ends of lines in katakana characters makes for a flamboyant look. All kinds of variations can be made without using any particular techniques.

Add a circle to the end

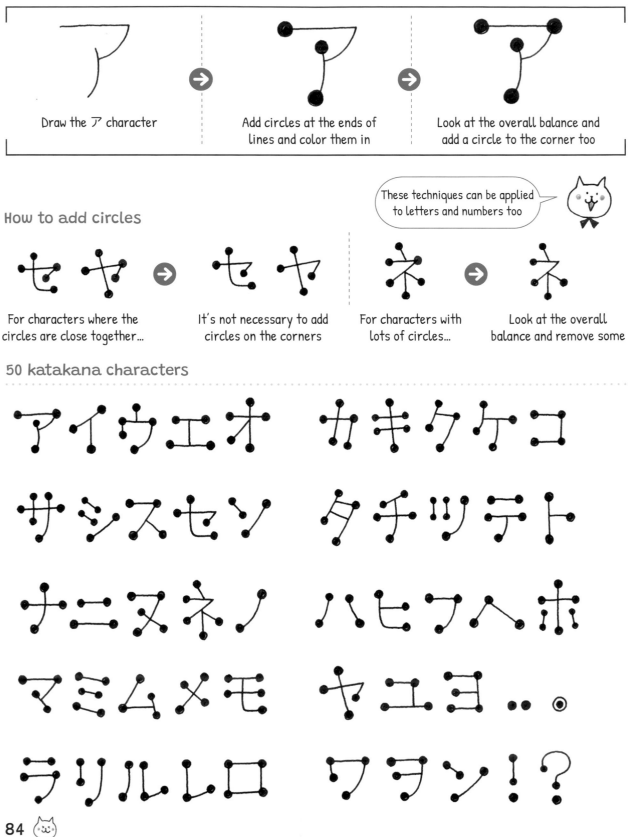

Draw the ア character

Add circles at the ends of lines and color them in

Look at the overall balance and add a circle to the corner too

How to add circles

These techniques can be applied to letters and numbers too

For characters where the circles are close together...

It's not necessary to add circles on the corners

For characters with lots of circles...

Look at the overall balance and remove some

50 katakana characters

アイウエオ カキクケコ

サシスセソ タチツテト

ナニヌネノ ハヒフヘホ

マミムメモ ヤユヨ‥◎

ラリルレロ ワヲン！？

84

Let's try variations on the basic font

Using triangles or thick lines instead of circles changes the overall look. Try altering the characters to correspond with the meaning of the phrase or the image you want to convey.

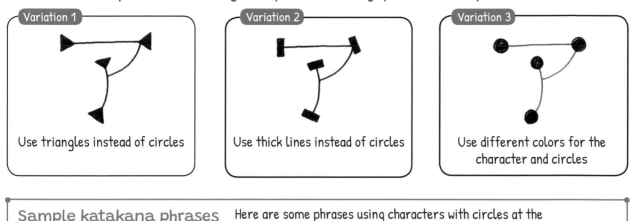

Variation 1
Use triangles instead of circles

Variation 2
Use thick lines instead of circles

Variation 3
Use different colors for the character and circles

Sample katakana phrases

Here are some phrases using characters with circles at the ends, along with variations on that style. You can use whatever shape you like on the ends so try using your favorites.

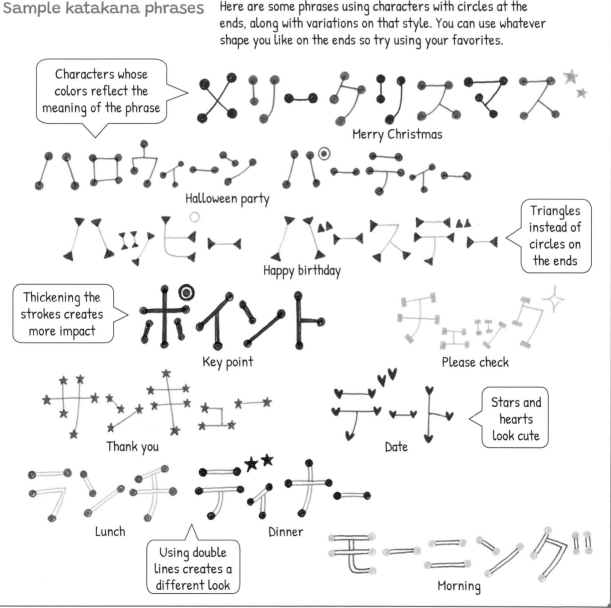

Characters whose colors reflect the meaning of the phrase

Merry Christmas

Halloween party

Triangles instead of circles on the ends

Thickening the strokes creates more impact

Happy birthday

Key point

Please check

Thank you

Date

Stars and hearts look cute

Lunch

Dinner

Using double lines creates a different look

Morning

85

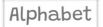 **Alphabet** — When making letters of the alphabet, using double lines is an effective yet simple technique for creating a stylish result.

Double lines

Write the letter A → Double the long lines → Check the overall balance and double the short line too

Tips for creating letters

A M P — Make the letter slightly tall when you first write it... → A M P — ...in order to achieve good balance when you double the lines.

Capital letters

A B C D E F G H I

J K L M N O P Q R

S T U V W X Y Z

Lowercase letters

For detailed lowercase letters, it's fine to just double the line of one section.

a b c d e f g h i j k l m n

o p q r s t u v w x y z ! ?

Create variations on basic lettering

Using triple lines, dotted lines and so on makes for completely different looks. Create variations to suit the shape of the letter or the meaning of the word in which the letters appear.

Variation 1
Change the color of the lines

Variation 2
Create triple lines

Variation 3
Use dots for the outer lines

Examples of the alphabet in use

These are examples of letters using double lines and other variations.

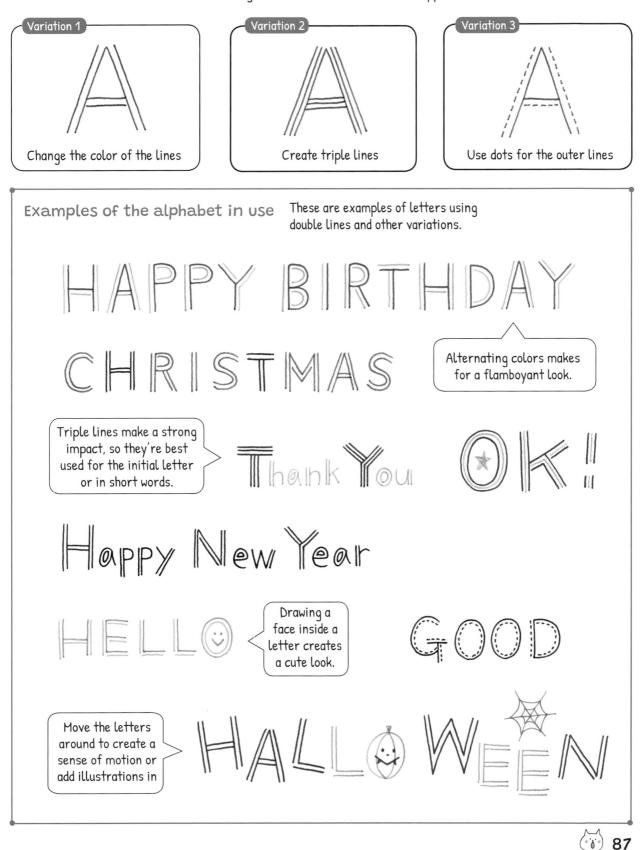

HAPPY BIRTHDAY

CHRISTMAS

Alternating colors makes for a flamboyant look.

Triple lines make a strong impact, so they're best used for the initial letter or in short words.

Thank You OK!

Happy New Year

HELLO ☺ Drawing a face inside a letter creates a cute look.

GOOD

Move the letters around to create a sense of motion or add illustrations in

HALLOWEEN

Decorative lines

Adding decorative lines to letters and characters in small doses makes for an attractive result. They can also be added to plain notepaper, sticky notes and so on to create original pieces.

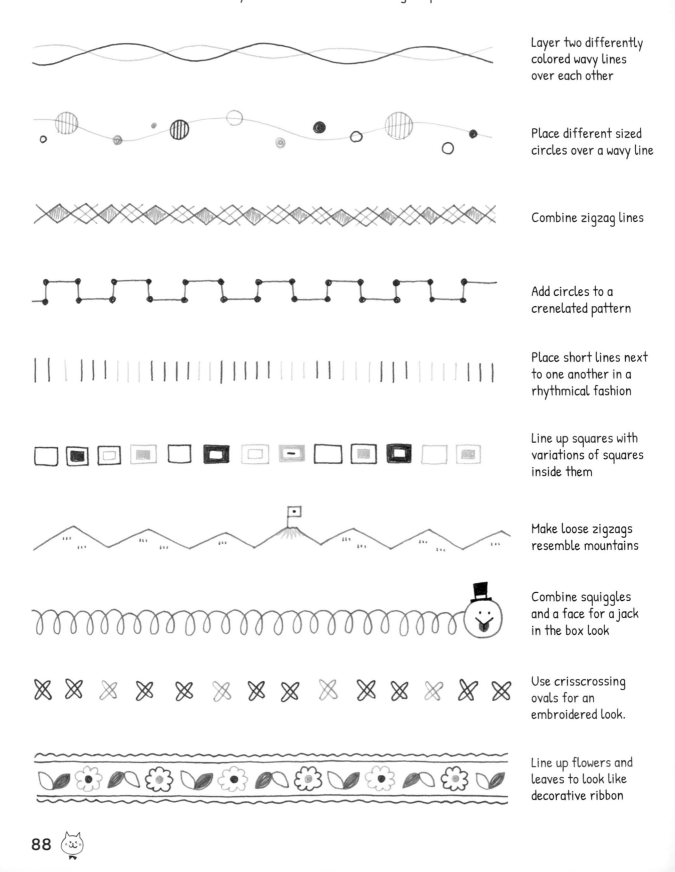

Layer two differently colored wavy lines over each other

Place different sized circles over a wavy line

Combine zigzag lines

Add circles to a crenelated pattern

Place short lines next to one another in a rhythmical fashion

Line up squares with variations of squares inside them

Make loose zigzags resemble mountains

Combine squiggles and a face for a jack in the box look

Use crisscrossing ovals for an embroidered look.

Line up flowers and leaves to look like decorative ribbon

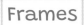
Frames

Adding a frame to messages and notes really sets them apart!
Try adding them to notes, greeting cards and business cards.

Cat and paw prints

Mouse with exercise wheel

Leaves and red berries

Phone and cord

Tree and birds

bicycle and tire tread

ribbon

Flag blowing in the wind

89

Summer greetings

The ability to create decorative lettering makes it easy to dash off summer greetings. Try to come up with fun designs that will make the recipient momentarily forget the heat.

暑中お見舞い
申し上げます

I hope you are well in this summer heat.

残暑お見舞い
申し上げます

kamo.

I hope you are well in this summer heat.

Christmas cards

There are plenty of adorable motifs for Christmas, such as the tree, Santa Claus, candles and so on. Use decorative letters too for a stylish result.

When placed in the envelope...

When the card is folded in two, the cityscape lines up with the starry sky, creating a moment of enjoyment when the envelope is opened.

Christmas Party
12/25
At Yamada's house 5pm

See the instructions on page 93

Merry Christmas

See the instructions on page 93

CHRISTMAS
PLEASE ENJOY CHRISTMAS!

New Year's cards

It's always tricky to come up with designs for New Year's cards, so it's handy to be able to draw the zodiac animal for that year. Individuality to your card and really set it apart.

See the instructions on page 93

あけまして
おめでとう

今年もよろしくね

HAPPY
NEW YEAR

今年もよろしくお願いします

あけまして
おめでとう

20YX

How to make a Santa Claus Christmas card (page 91)

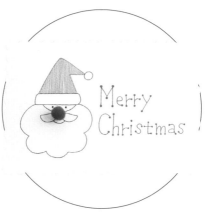

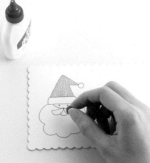

Draw Santa Claus and use glue to stick a red felt ball to his nose.

Decorative felt balls can be found at craft shops and dollar stores.

How to make a Christmas card with a cityscape (page 91)

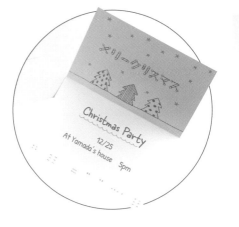

1 Sketch in the cityscape along the edge of the card (when open, this is the lower edge of the card)

2 Cut out with a blade and draw illustrations on the inside.

How to make a paperweight decoration (page 92)

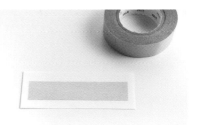

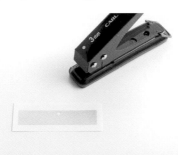

1 Stick silver masking tape onto paper. Here, we've used pasteboard to make it easier to work with the masking tape, but you can use whatever paper you like.

2 Use a 3mm holepunch to make a hole in the center of the tape near the edge.

3 Cut the tape and paper together into a paperweight shape. Remove the tape from the pasteboard and stick it to the card.

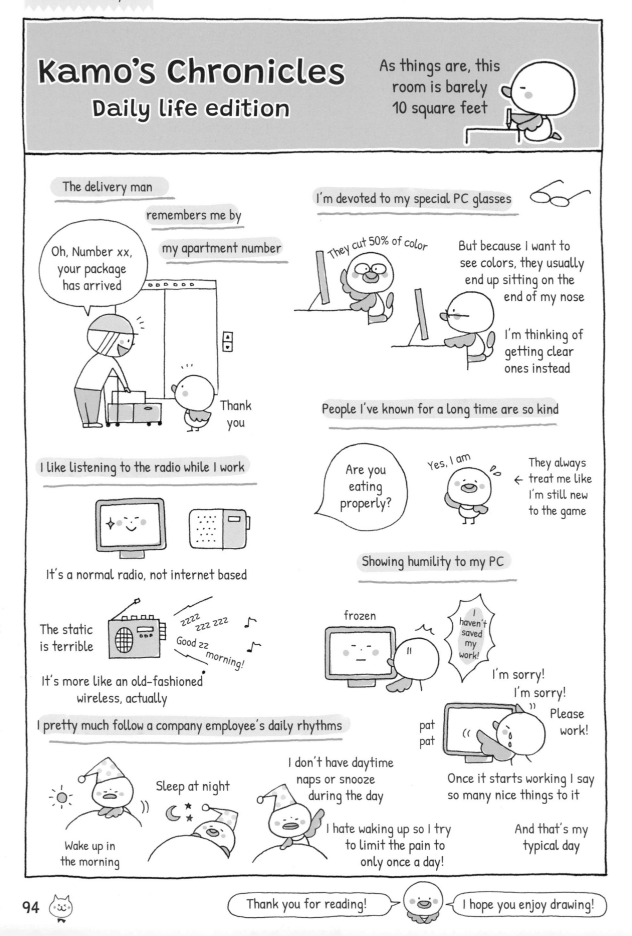

Kamo's Chronicles
Daily life edition

As things are, this room is barely 10 square feet

The delivery man remembers me by my apartment number

Oh, Number xx, your package has arrived

Thank you

I like listening to the radio while I work

It's a normal radio, not internet based

The static is terrible

zzzz zzz zzz

Good zz morning!

It's more like an old-fashioned wireless, actually

I pretty much follow a company employee's daily rhythms

Wake up in the morning

Sleep at night

I don't have daytime naps or snooze during the day

I hate waking up so I try to limit the pain to only once a day!

I'm devoted to my special PC glasses

They cut 50% of color

But because I want to see colors, they usually end up sitting on the end of my nose

I'm thinking of getting clear ones instead

People I've known for a long time are so kind

Are you eating properly?

Yes, I am

They always ← treat me like I'm still new to the game

Showing humility to my PC

frozen

I haven't saved my work!

I'm sorry! I'm sorry! Please work!

pat pat

Once it starts working I say so many nice things to it

And that's my typical day

Thank you for reading!

I hope you enjoy drawing!

About the Artist
Kamo

Superstar illustrator Kamo worked as a designer at an advertising production house before becoming a freelance illustrator, focusing on characters and advertisements before expanding into videos and consumer products. She teaches illustration courses in Japan and internationally. Kamo is co-author of *How to Draw Almost Everything for Kids* and author of *How to Draw Almost Every Day*, as well as two recent Tuttle releases: *How to Doodle Everywhere* and *How to Doodle Year-Round*. You can find her on Instagram @illustratorkamo.

"Books to Span the East and West"

Tuttle Publishing was founded in 1832 in the small New England town of Rutland, Vermont [USA]. Our core values remain as strong today as they were then—to publish best-in-class books which bring people together one page at a time. In 1948, we established a publishing office in Japan—and Tuttle is now a leader in publishing English-language books about the arts, languages and cultures of Asia. The world has become a much smaller place today and Asia's economic and cultural influence has grown. Yet the need for meaningful dialogue and information about this diverse region has never been greater. Over the past seven decades, Tuttle has published thousands of books on subjects ranging from martial arts and paper crafts to language learning and literature—and our talented authors, illustrators, designers and photographers have won many prestigious awards. We welcome you to explore the wealth of information available on Asia at **www.tuttlepublishing.com**.

Published by Tuttle Publishing, an imprint of Periplus Editions (HK) Ltd.

www.tuttlepublishing.com

DAREDEMO KANTAN & KAWAIKU KAKERU! KAMO SAN NO BALL-PEN ILLUST
© 2015 Kamo
English translation rights arranged with NHK Publishing, Inc.
through Japan UNI Agency, Inc., Tokyo

Library of Congress Cataloging-in-Publication Data in process
ISBN 978-0-8048-5380-4
ISBN 978-4-8053-1669-6 (for sale in Japan only)

English Translation © 2021 Periplus Editions (HK) Ltd.

The original Japanese edition contains handwritten characters within the illustrations. In the English edition, these handwritten Japanese characters have been replaced, where necessary, with standard fonts and typefaces.

Distributed by

North America, Latin America & Europe
Tuttle Publishing
364 Innovation Drive
North Clarendon, VT 05759-9436 U.S.A.
Tel: 1 (802) 773-8930
Fax: 1 (802) 773-6993
info@tuttlepublishing.com
www.tuttlepublishing.com

Japan
Tuttle Publishing
Yaekari Building, 3rd Floor
5-4-12 Osaki
Shinagawa-ku
Tokyo 141 0032
Tel: (81) 3 5437-0171
Fax: (81) 3 5437-0755
tuttle-sales@gol.com

Asia Pacific
Berkeley Books Pte. Ltd.
3 Kallang Sector, #04-01
Singapore 349278
Tel: (65) 67412178
Fax: (65) 67412179
inquiries@periplus.com.sg
www.tuttlepublishing.com

24 23 22 21 10 9 8 7 6 5 4 3 2 1 2103TP

Printed in Singapore

TUTTLE PUBLISHING® is a registered trademark of Tuttle Publishing, a division of Periplus Editions (HK) Ltd.